# GUSTÁVE DORÉ

# GUSTÁVE DORÉ

## NIGEL GOSLING

## PRÁEGER PUBLISHERS

### NEW YORK·WASHINGTON

BOOKS THAT MATTER

Published in the United States of America in 1974
by Praeger Publishers, Inc.
111 Fourth Avenue, New York, N.Y. 10003

**Library of Congress Cataloging in Publication Data**

Gosling, Nigel.
  Gustave Dore.

  1. Doré, Gustave, 1832–1883.
ND553.D7G67          759.4          73-13525

Printed in Great Britain

# CONTENTS

# LIFE

For Gustave Doré childhood was not only a launching-pad; it was an experience which marked him for good. It was spent in a rather special time and place. He was born in Strasbourg in 1832. In France the bourgeois Louis Philippe was stifling memories of the Revolution; in Britain the Reform Bill was establishing middle-class rule. The tide of the Industrial Revolution was washing over Europe. A new age was emerging from the old. In that year Goethe died and Manet was born.

His birthplace too was on a borderline. Doré was French and became a Parisian, but if he had been born six miles further east he would have been a German. This mixed inheritance was to become a key factor in his art, giving it a nordic intensity and roughness married to southern baroque harmonies.

He came from a well-to-do family. His paternal grandfather, an officer under Napoleon, had been killed at Waterloo and his father, Pierre Louis Christophe, became an engineer in the Department of Bridges and Highways. His mother's family, the Plucharts, were prosperous Alsatians from Schirmeck. Louis Christophe Gustave was the second son—born on 6 January, a week after his parents' arrival in Strasbourg, in an apartment in a smart street, at 6 (now 16) rue de la Nuée Bleue. He found himself in a tight and cosy family with a busy father, an irritable but doting mother, a rich grandmother (Pluchart), a one-year old brother, Ernest (another brother, Emile, was to be born a year later) and a nanny who was to serve him all his life and watch over his deathbed, Françoise.

It was a sheltered environment which did not change much when the family moved to another apartment, this time in 5 (now 2) rue des Ecrivains, a corner house—since demolished—dominated by a feature which was to appear in many of Doré's drawings, a Renaissance spiral staircase. The house lay almost in the shadow of the great red gothic cathedral with its immensely tall and elaborate towers, its angels and monsters soaring to celestial heights. It was not quite visible from his window—the eighteenth-century college blocked the view—but he had to pass under it every day on his way to school, an establishment on the cathedral square run by a M Vergnette. Like the staircase, it was to stay printed on his memory, part of his rich image-bank.

One of Doré's most attractive traits was that he kept many of his schoolfriends for life. Here he met two little relatives of the mayor, called Kratz, and one of them Arthur, was to be his closest intimate in Paris. Doré seems to have been a lively and popular little boy, drinking in the sights offered by the gabled streets and the pinewoods and dark

ravines of the surrounding country, through which his father sometimes took him when making one of his surveys. 'It was from these sights that I conceived those first vital impressions, those dazzling childhood visions which determine a taste in art,' he declared in a scrap of autobiography dictated to his mother when he was thirty-three.

Like most of his family, he had a musical bent (Ernest was to become an amateur composer) and was already studying the violin. His first visit to the opera seems to have much impressed him. It was Meyerbeer's *Robert le Diable* and his mind was filled with witches and goblins. He had a natural taste for the theatre, and there was much dressing up and many amateur performances at the comfortable country home of the Kratz family. At the age of ten he won a local notoriety by organising, and also decorating, a pageant for M Vergnette's birthday. Burlesquing a recent celebration of the four hundredth anniversary of the invention of printing by a local worthy, Johann Gensfleisch (better known as Gutenberg), he paraded decorated floats round the cathedral square, riding in the first dressed as Rubens, with pencil in hand and scattering lightning sketches to the crowd. It was a prophetic gesture for a child whose career was to combine emulation of famous artists with the production of popular graphics. From the earliest age his pencil had been almost as natural a part of him as his big toe. In the lamplight after supper, while his father sat chuckling over the latest Daumier or Gavarni in *Charivari* and his grandmother nodded over her Molière, Gustave would sit in a corner with his notebook filling the pages with little scenes and figures—doll-like groups imitating the Swiss cartoonist Toepffer or bird- and animal-headed men inspired by Grandville, caricatures of his family, notes of characters seen in the town. His grandmother frowned at such a waste of time but his mother was impressed. 'He will be an artist,' she declared, and asked him: 'When did these people sit for you?' 'Sit?' replied Gustave arrogantly, 'I have them all here, in my head—why should I not draw them?'

Though never a scholar, he was obviously bright. 'I am jolly pleased to have come first,' he wrote aged six to his chum Kratz. 'Now I have 10 francs in my purse. Look at the Grandville at the top of the page, it's an ant representing Barbotte returning from college with the certificate of honour.' Beside the insect, 'Barbotte' had drawn a surprisingly adult portrait of his teacher.

When he was eleven his father was transferred—partly through the manoeuvres of the ambitious Mme Doré—to Bourg-en-Bresse, capital of the Ain department, in order to survey the new Geneva–Lyon railway. Lying on the banks of the Saône in a setting of mountains and misty lakes, it provided another picturesque background for the boy's dreams. He spent five formative years there, often accompanying his father into the Vosges or visiting a friend a few years older than himself, Charles Robin. Robin too remained a close friend.[1]

Doré was a demi-pensionnaire at the local Olivier College. Here he was encouraged by the headmaster, M Grandmottet, to scribble in the margins of his Lhomond grammar, to sketch the locals, and was even commended when he showed up a drawing of the Death of Clitus instead of writing about it. He carried off the Latin prize in 1845 and—more significantly—the drawing masters, MM Cotton and Peingeon, awarded him their prize the next year.

He was busy at home with his pencil as usual, and also with a newly

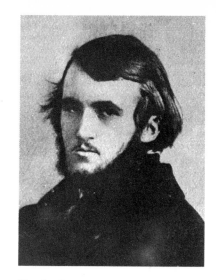

*Doré about 1850. Photograph by Nadar*

[1] He became a doctor and was probably responsible for Doré's many medical cartoons and work in medical journals. As an intern at La Charité hospital in Paris he may also have induced him to help decorate the Salle de Garde, with a burlesque Day of Judgement, demolished in 1932.

acquired box of oil paints.² There are records of several sketches of local characters which show a new independence. He found time to present a girl-friend with an album of forty-six drawings. And some local scenes—the unveiling of a statue to a certain M Bichat, a rustic concert and some children on a local slide, 'La Martinoire'—so impressed a printer in nearby Cézériat that he persuaded him to transfer them on to stone and published them as lithographs. They were Dorés first professional graphics.

The artist was eleven, and not above practical jokes—there is a story of a white hen mysteriously turning green overnight—but Mme Doré had ambitions for him. On a visit to relations in Paris, she found the opportunity to show some of Gustave's drawings to the artist Horace Vernet. 'The child has talent,' he said after examining them. 'Be careful not to put him under a teacher, who could only spoil his gifts.' It may have been fateful advice.

In 1847 M Doré took to Paris not only his wife and some drawings but Gustave himself. The artist described the visit later: 'One day, after staring for some minutes at the shop-window of Aubert and Philipon on the Place de la Bourse, I returned to my hotel and it fortunately occurred to me to dash off a few caricatures in the style of those at which I had been looking. Taking advantage of the momentary absence of my

*Doré about 1870. Photograph by O. G. Rejlander*

9

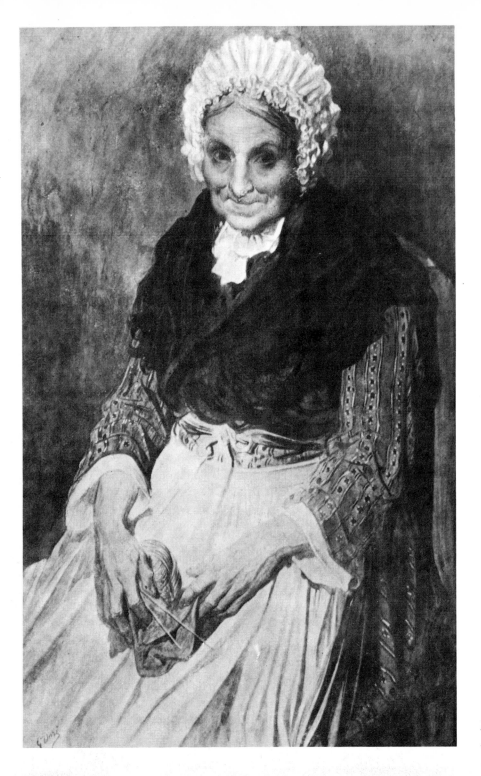

parents, I ran back to the shop and presented my little drawings to the well-known publishers.

'M Philipon examined my sketches kindly and attentively, questioned me minutely about my position, and then sent me back to my parents with a letter inviting them to come and have a talk with him about me . . . Eventually he obtained their permission for me to remain in Paris, assuring them that henceforth he would use my sketches and pay me for them.'

M Doré hesitated for six months before making a final decision, but

evidently Philipon made a good impression. On 15 April 1848, he returned the publisher's contract: 'I did not even need a written document; your word would have perfectly sufficed, and I like to believe that you would not have doubted mine when spoken on behalf of Gustave. He is a young man imbued with honourable and correct sentiments and you may rely upon it that he will never fail to fulfil any of his engagements.'

The contract[3] between Philipon and M Doré, 'anxious to develop the talent of his son, Gustave Doré aged sixteen, in the profession of lithography', guaranteed such work to the boy 'both in pen and pencil'; in return he was to produce a cartoon every week, unless prevented by school attendance or sickness. He was to receive fifteen francs for the pencil drawings and forty for pen and ink.

It was a climactic moment. 'From that day,' Doré recorded later, 'it was decided that I might give myself up to my own inclinations.' He was joining a powerful figure. The discovery of lithography early in the century had enabled drawings to be reproduced in large numbers and opened up a new outlet for impecunious young artists[4] and a new chance for poor readers to learn about, and laugh at, the world around them. Following the birth of *Punch* in England in 1841 and *Fliegende Blätter* in Germany in 1843, the firm of Aubert and Philipon had launched *Caricature* and *Charivari*. But the latter had had to close down after a libel action, and when Doré appeared Philipon was just hatching a new, less fighting substitute, the *Journal pour Rire*.

The young contributor had to fill a whole page each week, usually on a single theme. In the first number he was allotted page four, which he devoted to an innocent subject, New Year gifts. He was part of a distinguished team. Philipon, a forty-eight-year old Lyonnais, had started as an artist himself but been seduced by the success of men like Cruikshank and Gilray in England. He had a journalist's ambitions and an eye for talent—his team had included Gavarni, Grandville, Cham and the pugnaciously radical Daumier, whose cartoons had sunk the *Charivari*.[5]

The engagement of very young men was not unusual with him, or indeed, others. One of Doré's new colleagues, Felix Tournachon, had published his first drawing with the firm at the age of sixteen (later he changed his name to Nadar and made a career in photography), and another, Paul Lacroix, had had a tragedy produced at the Odéon at eighteen.[6] All the same, the production of a sheet of drawings and captions must have been a stiff task for a boy who had simultaneously enrolled as a demi-pensionnaire at the celebrated Charlemagne College.[7] He paid the fees from his own earnings and luckily lodged nearby, with a friend of his mother, Mme Hérouville, in the rue St Paul. Better still, both school and home lay next door to the Musée du Louvre and the Bibliothèque Nationale with its hoard of engravings; Doré spent hours in both, noting details of costume and architecture.

His lively cartoons suited the now cautious Philipon perfectly, dealing as they did with harmless public foibles rather than politics, and he made shrewd publicity of the artist's youth. He had got hold of an album Doré had made at Bourg, and produced it with a tempting foreword: '"The Labours of Hercules" has been written, drawn and lithographed by an artist fifteen years old, who has learnt to draw without a teacher or an art lesson. This seems to us not the least interest-

[3] Reproduced in *Le Figaro* 4 Dec 1884
[4] Delacroix, for instance, contributed in his youth to *Le Nain Jaune*.
[5] In 1842 he was apologising to his readers that he could produce his *Musée Philipon* only fortnightly owing to 'the difficulty of printing 30 or 40 designs in one week'.
[6] Called *Le Prison de Pompeia*, it was withdrawn after one performance.
[7] Fellow-pupils included the future historian Henri Taine and Edmond About, who later became a helpful critic.

ing feature of the album and we wish to record the fact not only in order to draw the attention of the public to the work of this young draughtsman, but also to mark the debut of M Doré, whom we believe destined to occupy a distinguished place in the arts.' The little sketchbook, which had forty-six pages with two or three drawings on each, was a brilliantly inventive satire (in the style of Cham) on the Hercules myth—a symptom of the romantic attack on neo-classicism which had been launched some years earlier. He became the archetypal infant prodigy, drawing stares when he visited the libraries and laughs when he played the fool at parties. His vitality burst out in physical stunts like walking on his hands and playing practical jokes. 'At Philipon's there's a kid who does somersaults like a monkey and draws like an angel,' Nadar told a friend.

His cheerful irresponsibility alarmed his friend Lacroix, who shrewdly told him that he was 'unprofessional' and should attend some art-classes—advice which was contemptuously dismissed. It was at this time that the celebrated Théophile Gautier—admired by the young, though already forty—on being introduced by a colleague of Doré on the paper, Paul Dalloz,[8] fitted him with the penetrating label 'un gamin de génie' (an inspired urchin).

He was well launched, but on a road he was soon to regret. In his subsequent autobiographical notes he wrote: 'The study of caricature was not much to my taste and although for five years I produced innumerable drawings, this was simply because the only publisher to accept my work had one exclusive speciality. This speciality was caricature and the publisher was Philipon . . . At last, about 1853, I found an excuse to free myself from the topicalities of comic work, which was a source of extreme irritation to me.'

In fact these topicalities involved almost at once the horrors of the 1848 Revolution, which he witnessed in the Faubourg St Antoine; but his reactions were much less vivid than those of Daumier. Versatility, not profundity or integrity, was to be his strength. His dexterity was amazing. He soon learned to draw, like a professional, straight on to the wood, and already in 1848 he had two pen drawings in the Salon.

The escape-clause in his contract was soon invoked, for Mme Doré arrived to sweep her son away for a seaside summer holiday. On their return his society-minded mother joined him in the rue St Paul, deserting her husband who stayed behind in Bourg. Retribution came fast and suddenly. On 4 May 1849, after the briefest illness, M Doré died. A few days later, a pathetic letter, signed by one of the worthy engineer's colleagues, was addressed to his superiors: it was a request for assistance for the bereaved family—to get the elder son, Ernest, into the École Polytechnique and the youngest, Emile, into the military academy of St Cyr. As for Gustave: 'He needs no assistance. Already well-known as an artist for two years, although barely seventeen years old, he is at present working with Henry Scheffer and doing drawings for Philipon. His parents had restrained him in this all too easy career of caricaturist and he has already been studying seriously for the future. A notable young man of high character, he will, if he is properly guided, become an exceptional artist (on this there is general agreement), but for that he certainly needs a quiet life free from practical and emotional distractions. His talent must, if I may use the expression, ripen in a hot-house, sheltered from the hardships of life. The death which has struck

*Drawing made aged five*

8 Later editor of *Le Moniteur Universel*.

*Bourg peasant, drawn at the age of nine*

down his father will compel him to draw for money. Alas! A rare talent will shrivel without fail. However, I still have hopes . . . signed: Ferrand. Bourg. 6 May 1849.'

The 'sheltered hot-house' materialised within a few weeks, through the death of Mme Doré's mother, the rich and kind old Mme Pluchart. M Doré's pension was liquidated at the end of the year for a mere 661 fr, and Mme Doré had otherwise only 1000fr from a property; but now she inherited not only half of a handsome house in a smart part of Paris, 73 (now 7) rue St Dominique, just off the Boulevard St Germain, but also enough money to buy up the other half (originally allotted to her brother) when it came up for sale two years later at 65,000fr.

The excitement for a teenager of a move into a large and comfortable new home was increased by the tradition that it had once belonged to the famous eighteenth-century statesman and diarist, the Duc de Saint Simon. Gustave's imagination took fire. Recovering rather quickly from her bereavement, Mme Doré gave a house-warming party at which Gustave organised a charade, with friends and family dressed up as characters from the great man's diary. He had already

13

*Doré's mother. Watercolour, 1879*

smashed a chandelier by trying to stand on his head on the dining-room table.

His horizons widened by new affluence, his ambitions swelled accordingly. He rented a large studio in the nearby artistic student quarter. In the elegant courtyard of 22 rue Monsieur-le-Prince, near the Odéon—once reputedly the home of the sixteenth-century sculptor Jean Goujon—he began to work on giant pictures.[9] In 1850 he showed his first paintings at the Salon, 'Les Pins Sauvages' and this seems also to be when he painted a striking circus group 'Les Saltim-banques'.

His activities at this formative time are rather mysterious. He derided art tuition—especially, no doubt, the still classically oriented École des Beaux Arts—and steadily affirmed that he was self-taught, apart from some brief lessons from one modest teacher.[10] But M Ferrand's moving plea for assistance for the family expressly mentions 'serious study' with Henry Scheffer. This young Dutchman was a brother of Ary Scheffer, a successful artist who had been a fellow-pupil of Géricault in Guérin's anarchic studio.

Doré must certainly have met Géricault and his circle. He was much influenced by their romantic style, and must have longed to emulate them. But he was not prepared to sacrifice his facile successes to study. He was more inclined to imitate their manner than their methods, and comforted himself with his popularity. 'Look!' he exclaimed to Lacroix. 'I am paid and paid well. That means I am just as good as the others. I am an artist, that's obvious.' But he was to kill himself trying to prove it.

Success was certainly coming fast. His *Hercules* booklet was followed four years later by a collection from the magazine titled *Ces Chinois de Parisiens*, and in the same year, 1851, appeared not only 134 drawings for Lacroix (who wrote under the curious name of 'Bibliophile Jacob') but two light-hearted books called *Les Désagréments d'un Voyage d'Agrément* and *Trois Artistes Incompris* totalling 130 lithographs and a lively text.[11] At the same time he brought out thirty original litho-graphs poking fun at establishment figures like lawyers and doctors. After only three years with the *Journal pour Rire* he had published 700 drawings and five albums. He had exhibited twice at the Salon and was so avid for further work that he offered (not always successfully) several drawings to editors free of charge.

Such an output for a schoolboy might seem enough. But Doré's young energies seemed inexhaustible. He plunged eagerly into the amusements of a city which was at that time noted for its pursuit of pleasure. He frequented the opera houses and theatres, worshipped the stars, and bathed in the music of Meyerbeer, Gounod and his beloved Rossini. He played the piano (indifferently), acted, sang and even took violin lessons with a director of the National Opera, M Vaucorbeil.

Slim and pale, with a lively expression and bubbling vitality, he began to be a familiar figure on the artistic scene. But his dreams were already soaring to absurd heights, and the public pet had moments of bitter envy and gloom. He quarrelled with his friend Dalloz when he criticised one of his paintings, and complained already that he was misunderstood. The popular cartoonist was set on being saluted as a Great Artist.

His social and artistic activities were made possible by a trouble-free

[9] According to Blanche Roosevelt, in her *Gustave Doré*, 1885, Lacroix counted twenty-five stacked against the wall, and Gautier in his *Arts en Europe* 1855 describes the studio as 'bulging with huge canvasses dashed off with a frenzy outstripping Goya and then abandoned and repainted in a chaos of colours.'

[10] He charmingly signed his 1853 Salon painting, 'Les Deux Mères', 'Gustave Doré, pupil of M. Dubois'. This teacher, a professor at the College of St Louis, gave 'lessons in painting and drawing' at 33 rue Richer.

[11] The latter ended with a note piously hoping that 'Gustave Doré's albums will always insist on embel-lishing nature and sad reality.'

Les Travaux d'Hercule, *1847*

domestic background. The 'hot-house' in the rue St Dominique was run by the faithful Françoise and presided over by his ever loving and admiring mother. His little room opened straight out of her handsome blue bedroom, and this was where he loved best to work. Psychologically he never left it.

Apart from a single illustration in a travel-book,[12] 1852 was spent in journalism, but in 1853 he carried out a set of drawings for a cheap serialised edition of Byron. The subject, curiously, did not inspire him; the drawings are conventional costume scenes. It was to be the next year—his twenty-second—that really marked his début.

He started with a novel by Brot, *Le Médecin de Cœur,* and then brought out two brilliant lithographic albums depicting Parisian life— *Les Différents Publics de Paris* and *La Ménagerie Parisienne,* both issued by Le Journal Amusant. These scored an easy success; but they did not foreshadow his next two works, which were to establish his reputation resoundingly in two completely different fields.

His *Histoire de Sainte Russie* hit a topical nail right on the head. The reactionary Tsar Nicholas, at the head of the biggest army in the world, was the bogey-man of the day, and France's fears had exploded in the Crimean War, declared that year, 1854. Doré's savagely inventive book of cartoons, the nearest he was to get to politics, combined patriotic bias with a witty pictorial style in over 500 drawings.[13] Its success was

12 Edouard Texier, *Tableau de Paris*
13 A Harvard Professor, Richard Pipes, has suggested that it was inspired by a travel book of the Marquis de Custine of 1839.

immediate with admirers of his magazine illustrations; but his next book carried him into new fields.

This was an illustrated version of the celebrated but difficult classic, Rabelais's history of *Gargantua and Pantagruel*. Lacroix provided an introduction and a publisher, J. Bry. The book was issued in the *Journal pour Rire* formula, in instalments at 20 centimes each. Doré had been working privately on the subject for over a year, looking out for a publisher, and he came up with 200 drawings, besides sixteen full-page plates. The paper was miserable and the printing atrocious; but the impact of the illustrations was immediate. Alexandre Dumas's journal *Le Mousquetaire* devoted a whole issue to its merits,[14] and Doré's name became widely known.

Success came just in time, for he was in low spirits. A family holiday in the Alps had helped, but a visit to Strasbourg—where his old friends seemed unimpressed by the young genius from Paris—cast him down. 'He heartily despises these compatriots, who did not receive him any too well,' wrote his mother. His pique is understandable, for in Paris he was now in great demand, especially among publishers with books on medieval subjects on their lists.

But he was already afraid of becoming type-cast. He had taken his notebooks and paint-boxes on his travels ('His album is full of sketches,' noted his mother) and seems to have been experimenting with both water-colours and oil. Back in Paris he worked up some landscapes

Trois Artistes Incompris, *1851*

and embarked on a series of paintings which revealed a significant and hitherto repressed side of his character. They were the result of wanderings through Paris with Bohemian friends like Gautier and the gentle poet Labrunie (who wrote as Gérard de Nerval). Twelve enormous canvases in the detested Realist style depicted the poor quarters of the capital under the title of 'Paris Comme elle Est'. Gautier himself saw and liked the pictures[15] but, not surprisingly, they found no local buyer. They were sensational enough for an American showman to offer no less than 110,000fr for them, but Mme Doré insisted on even more; the deal fell through, and they disappeared—probably destroyed by the artist. They were to be reborn nearly twenty years later in his studies of the slums of London.

Cautious about repeating himself though Doré might be, he succumbed to the temptation of another medieval subject suggested by Lacroix, who lent him Balzac's *Contes Drolatiques*. Two weeks later Lacroix met him and asked how he had enjoyed them. 'The drawings are finished!' announced Doré, and he produced twenty blocks to prove it. He did over 400 plates in all (at around 80fr for each block this meant a considerable outlay) with ever-increasing verve and pictorial skill. But again the format was small and the production cheap and poor, and the book—now highly valued—was a commercial flop. Of the big initial print, 10,000 copies, many were later remaindered.[16]

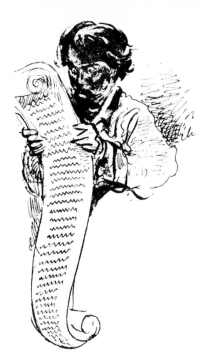

*Self-portrait with proofs, undated*

However, coming so quickly after his *Russie* and Rabelais, it established Doré in publishing circles as the rising star of illustration and demands poured in, from books on lion-hunting and gold-digging to pamphlets on current wars and fashionable fairy-tales. The last commission for 1855 was for a travel book by his old college friend Henri Taine on the Pyrenees. Accompanied by Paul Dalloz and Théophile Gautier, now something of a crony, he set out to absorb the region. The party arrived in Biarritz in time to join in festivities in honour of the emperor and attended a couple of bullfights, which upset Doré so much that at dinner Gautier had to rebuke him for acting like a baby. The two liked to argue about art: the huge critic—womaniser that he was—held that no beauty matched that of a beautiful woman, while Doré, significantly, defended the imaginary ideal. Pushing south into Spain they were in high spirits, joining in a practical joke which involved dressing up as coachmen and driving an empty carriage into an inn.

The trip must have helped Doré to forget the mortifications he had had to endure at the big Universal Exhibition celebrating the birth of the Second Empire, to which he had sent four paintings. One was rejected, two were acceptable landscapes. The fourth, called 'The Battle of Alma' and done in his usual slapdash style, came in for unfavourable comment. 'Why did you not study nature in the Crimea?' he was asked. 'Nature!' he retorted. 'What's that?'

His powerful friend Gautier defended him guardedly, but even he had reservations. 'We cannot say if this gentleman will ever free himself completely from the clouds which obscure him, but already the rays are pierced by a ray of genius—yes genius, a word we do not use freely. Naturally we speak only of the future of the painter: the draughtsman is already established.'[17]

As an illustrator he was indeed now established, and more commissions poured in. He worked for fame—but the money came in handy.

[15] So Paul Lacroix related to Blanche Roosevelt
[16] By a bookseller called Delahaye
[17] *Beaux Arts en Europe*, 1855

The big house in the rue St Dominique was expensive to run, and he was virtually the only breadwinner. Emile had left home and Ernest, abandoning his engineering ambitions, was starting up (all too shakily) as a stockbroker. Moreover, Doré was now a minor celebrity with appearances to keep up, and current styles of entertainment were lavish.

This was the bumper age of the bourgeoisie. Confidence was strong, appetites large, the market booming. Offenbach lifted the Parisians' spirits, Meissonier flattered their self-esteem. Output in the arts rivalled that in factory and mine. Victor Hugo gushed poetry like lava, Dumas turned out novels and plays like pancakes,[18] Gautier—not yet poetically pursuing 'the profile of Apollo in a vein of jasper'—was filling the critical columns with yards of elegant but uncorrected prose. The huge voices of Patti and Neilsson echoed round enormous opera houses. Parties grew larger and more expensive, paintings bigger and more crowded. In 1862 there were 4000 artists living in Paris[19] and the Salon had to accommodate 2000 pictures and multitudes of visitors. Afterwards the works were discussed in whole series of articles, often one by one in alphabetical order.

The whole of Paris was a kind of 'sheltered hot-house' now, forcing artistic talent at an incredible tempo. Establishment figures and rebellious bohemians, aristocrats, government officials and theatrical stars rubbed shoulders in a society which was competitive but not destructive. Doré found himself in a world where he was expected to live three lives simultaneously. Rising early he would slog all the morning at his blocks, spend the afternoon at his easel, go swimming in the baths, call in for a drink at one of the many artistic cafés, go on to a first night or a concert by Liszt or Berlioz (of whom he did a vivid caricature) and end up at a dinner or soirée with one of the fashionable hostesses.

To many of these he was first introduced by Gautier. Though twenty years his senior, he became an intimate and inestimably useful friend. Boisterous, amorous, and an indefatigable and highly professional worker, he was the most influential critic of the time, besides producing much original work of his own. Doré, an irrepressible entertainer, was a regular guest at Gautier's parties in Neuilly, where he must have met men like Flaubert (who liked to do an 'idiot' *pas de deux* with his host), de Musset and the Goncourt brothers. Perhaps it was there that he so impressed George Sand that she is reputed to have remarked to him solemnly: 'You have elevated your generation; you have made it more artistic.'[20]

Gautier has listed some of the engagements at the disposal of a young man like Doré; 'the Tuileries concerts, the Sundays of Princess Mathilde, the Thursdays of Princess de Metternich, the Fridays of the Comte de Nieuwekerke and General Fleury, the dinners of Mme de Paiva, the balls of the Duchesse de Ste-Clothilde and St Philippe du Roule, not to mention the concerts of M Garfounkell . . .' Of these Princess Mathilde, a daughter of Jerome Bonaparte and mistress of the Director of the Louvre, was especially influential. Next to her came Mme de Girardin, wife of a big publisher. At the home of the actress Rachel, who 'refused nothing to the poor and accepted every thing from the rich,' he would have met intellectuals such as Sainte Beuve, Merimée and Maupassant, while Rossini's Saturday parties were atten-

[18] Faced with simultaneous demands from Rachel and Sarah Bernhardt, he wrote two full-length tragedies in three weeks. See Arsène Houssaye, *Confessions: Souvenirs d'un Demi-Siècle 1830–1880*, 1885
[19] J. Lethève, *Daily Life of French Artists in the 19th Century*, 1972
[20] Quoted in an obituary

ded by singers, dancers and composers. He would probably have been an occasional guest at the 'dinêrs des Spartiates' at the Moulin Rouge restaurant and at the Figaro dinners at Vefours.

The tone at some of these receptions was permissive, with open (though private) drug taking at the Club des Haschouistes, mistresses and lovers freely recognised and wire-pulling a normality. But there were degrees of eminence even here, and artists rated low. 'How charming and witty M Delacroix is,' exclaimed a young girl on meeting the painter. 'What a pity he's an artist!'[21] Even more revealing is an entry in the Goncourt Journals describing a public ball.[22] 'Through an open window I watch the young mashers dancing. Among them, a white waistcoat covering his pointed little belly, is a dancer looking like a best man in his Sunday suit. It is Doré. Artists love these amusements, which give them a whiff of society. The whole literary world could pass by, and not one would take part in this hop.'

At this time the Goncourts were finding Doré antipathetic. 'He displeases me, this man—fat, fresh, baby-faced, with an expression like the moon in a magic-lantern and the complexion of a choirboy, an ageless look bearing no trace of his terrifying labours; to sum up, he displeases me with his air of an infant prodigy in the body of a grown-up.' Later even they were to relent, and to many people his gay, youthful temperament must have made him a welcome guest. He was expert at the *tableaux vivants* which were the craze of those years, and he loved to perform. 'There were moments of excitement,' wrote Gautier's daughter Judith,[23] 'when Gautier would try to play the piano and Gustave Doré would enter the room on his hands with his feet waving in the air, and proceed to play an amazing number of clownish tricks, at which he was inordinately clever.'

Doré was not only an acrobat but a skilled musical performer. He used to sing duets with his hostesses and he even dared to sing and play the fiddle at the enjoyable but alarming parties at the Rossinis in the rue Chaussée d'Antin. 'I want to introduce you to two young friends,' the composer said jovially to one of his visitors, 'M Plante, a pianist colleague, and M Doré, whom the world believes to be a great draughtsman but who is in fact a great singer . . . and therefore my colleague too.' The visitor agreed with the composer: 'Doré had a very beautiful baritone voice and sang with great taste and expression.'[24] On an occasion when Patti, Alboni and Delle Sedie were performing a trio (accompanied by Rossini) this was no mean compliment. His voice must have been remarkably flexible, for Rossini gave him a much-treasured photograph inscribed: 'To a distinguished violinist and a charming tenorino.'

Doré was not to be left out of the entertaining. He started a series of Sunday dinners (to be expanded in the big studio he rented later) at which he played host to celebrities like Liszt, Rossini, Saint-Saëns, Gounod, Patti, Bernhardt, Dumas *père* and Dumas *fils*, Taine, Gautier and painters like Hébert and Harpignies. His mother, looking like 'an accomplished gipsy in a semi-Andalusian style'[25] presided over the evenings, which were famous for their elaborate staging—such as dressing a whole meal *à la* Post Office in honour of the visiting Postmaster General.

This ebullient life exactly suited Doré's high-pitched but immature temperament and he swam in it joyfully, playing as hard as he worked.

21  Quoted by J. Lethève
22  18 Aug 1866
23  In her memoirs *Le Collier des Jours*, 1907
24  Tito di Giovanni in March 1867, quoted in Herbert Weinstock's *Rossini*, 1968
25  Paul Lacroix, quoted by Roosevelt

But it received a sudden jolt when, in March 1855, one of his friends, the much-loved poet Gérard de Nerval (an intimate of Gautier to whom Doré was perhaps drawn by a common interest in German culture) was found hanging one early morning from a railing in the rue de la Vieille Lanterne. The shock of this sudden death[26] is revealed nakedly in an extraordinary lithograph he made of the event—an ineptly drawn scene in which the plump poet in a frock coat dangles on the steps while a skeleton with a trumpet carries his soul aloft. It is—with an odd flagellation scene in *Don Quixote*—the nearest thing to a psychopathic drawing Doré ever made.

But nothing could restrain his ambitions. From the first he had been dissatisfied with the way his drawings had been engraved and—like many of his contemporaries—he formed a team of men who would specialise in his work. He demanded more and more from them and now he conceived the idea of mammoth-sized engravings. He chose as his subject *The Wandering Jew* and the plates were 18in by 12in. Today most of them look overloaded, but they certainly impressed his contemporaries in many countries. His reputation was now international and he began to overproduce seriously. In the next four years he was to publish 569 drawings in twenty books;[27] most of them worthless.

To start 1861 he threw off a hundred charming small drawings for a travel book by his friend Edmond About.[28] But his mind was on bigger game, as he admitted in his notes of 1865. 'My idea was . . . to produce in a uniform style an edition of all the masterpieces in literature.' He had thirty books in mind and reckoned that the work would occupy many years. His list was somewhat idiosyncratic. It included Dante, Perrault, *Don Quixote*, La Fontaine, Ariosto, Milton, Montaigne, Byron and the *Arabian Nights*—all of which he eventually illustrated—also *The Imitation of Christ, The Life of the Saints*, Homer, Virgil, Ovid, Aeschylus, Horace, Anacreon, Lucan, Tasso, Ossian, Molière, Racine, Corneille, Lamartine, Shakespeare, Spenser, Goldsmith, Goethe, Schiller, Hoffmann, Plutarch, Bocaccio, *Les Pages de Nidda, The Romancers* and the *Niebelungenlied*. Curiously, Victor Hugo is missing.

It is unlikely that any would have surpassed the very first one, to which he now devoted the whole of his attention—Dante's *Inferno*. As with his *Wandering Jew*, he had difficulty in finding a publisher to take the risk of the expensive venture.[29] Its success, both commercially and critically, justified his ambitions, but still something was missing. 'Gustave no longer eats or sleeps,' Mme Doré is quoted as saying. 'Is he, the greatest artist of his time, to be worried and cast down all for a miserable decoration that people not fit to tie his shoe-laces have had for a smile!' But in the end all was well. Through the intercession of Dalloz he was awarded the Cross of the Légion d'Honneur.

The resonant chiaroscuro of the Dante prints—an effect facilitated by the invention of zinc-engraving—was abandoned for his next works. For *Le Chemin des Ecoliers*, a satirical travel book in the old style by X. B. Saintine, he dashed off no less than 200 vignettes, and for the farcical story of *Baron Münchhausen* he did 150 suitably fantastic and exaggerated drawings in a coarse German vein. An aggressive mood emerges in his work this year, 1862, and it appeared to great effect in his next important book—one of his 'master-works'—the *Contes de Perrault*. More suitable, perhaps, for the gruesome tales of the Grimm

[26] 'He hanged himself because he saw his madness face to face,' explained his doctor, Dr Blanche, to the Church. The suggestion of insanity eased him into a funeral at Notre Dame.

[27] According to Henri Leblanc, *Catalogue de L'Oeuvre de Gustave Doré,* 1931

[28] *Le Roi des Montagnes*

[29] He sold the rights to the printer and two of his engravers, Rouger and Jahyer.

21

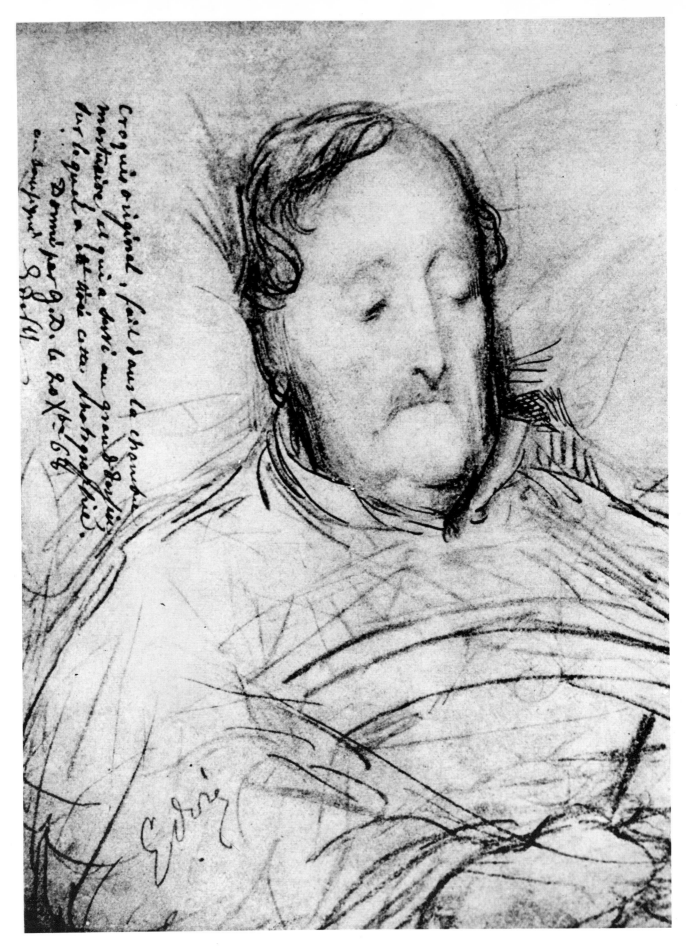

brothers than for the delicate eighteenth-century story-teller, they restored a fearsome actuality to legends which Perrault's delightful irony had lightly veneered with French polish.

The verso of this mood inspired the next of his 'master-works', which he tackled the following year: Cervantes' *Don Quixote*. Bringing together memories of his Spanish tour with his inimitable sense of narrative and adventure and a touch of sympathy for the luckless victim-hero which perhaps reflects his own feelings of isolation (he was still hankering after recognition as an artist),[30] he created what has become the archetypal image of the Don and his servant, Sancho Panza.

This book marks a peak in Doré's career. He was, as he ruefully noted, widely famous as an illustrator, and he seems also to have been —probably for the last time—in step with some of the progressive artists of the time. It was he, for instance, who in the Salon of that year— after the row which was to lead to the epoch-making 'Salon des Refusés'—joined with Manet in handing in to the authorities a protest at the way the selection had been handled.[31] But a version of the Bible (not one from his selected list), together with a *History of France*, put him back into favour with the Establishment. His status was confirmed when he was invited by the Emperor to spend ten days at Compiègne, as a fellow-guest of Offenbach and Dumas *père*. He was riding high and on 4 December he gave a grand ball.

But he was determined to break out of his graphic prison. 'My enemy is myself,' he declared boldly. 'I must kill the illustrator and be known only as a painter.'[32] He abandoned his old studio in the rue Monsieur-Le-Prince and—with the money coming in from his many publications, shrewdly handled with the advice of his old friend Arthur Kratz—built a studio onto the house in the rue St Dominque. Here his mother and Françoise could cosset him and flatter him while an old and thrifty servant, Jean, looked after the studio, sometimes scolding Doré for using such expensive colours.

For once social duties seem to have eaten into his work, for 1865 produced little.[33] Maybe he was devoting even more time to painting, for in 1866 he took on an enormous studio in the fashionable rue Bayard, near the Étoile.[34] Here he set up the conventional décor of bad Second Empire painters—suits of armour, rugs, antiques and drapes, mingled with cigar-boxes spilling bills and contracts, pug-dogs and a trapeze and horizontal bar on which he battled, vainly, to preserve his waistline.

He still travelled most summers to Italy, Switzerland or the Tyrol— usually in search of mountain scenery—but never far from the French frontier. However, a new country was beginning to edge into his attention. Several of Doré's books had appeared in English editions and proved very successful. In 1865 he had been visited by a London publisher, and next year a huge and well-printed edition of Milton's *Paradise Lost* appeared under the imprint of Cassell, Petter and Gilpin with fifty illustrations by Doré. They were not very successful. Satan, much influenced by Delacroix's visions of the Devil in his *Faust*, was fine, but as usual Doré proved much less at home with virtuous and peaceable characters, especially when one of them was a naked girl. But the venture was profitable, and the publishers returned with the suggestion that Tennyson should receive the same treatment. This evidently fired Doré's imagination to larger ambitions, nothing less

[30] The red-coated soldiers in 'La Bataille d'Inkermann' in the Salon had been compared to half-cooked lobsters and described as 'a thicket of shrimps'. Jules Claretie, *Peintres et Sculpteurs Contemporains*, 1883

[31] A suitably 'quixotic' gesture, as he had had three paintings accepted —see Ian Dunlop, *The Shock of the New*, 1972. One of these, a biblical scene of 'The Flood' was lampooned by Cham as 'a tiger devouring its young rather than fall into the hands of the bourgeois recommended to it by M. Doré'.

[32] See J. Valmy-Baysse, *Gustave Doré*, 1930

[33] According to Henri Leblanc he did only seven drawings this year.

[34] Now demolished and rebuilt, appropriately housing an art publisher.

than the complete Shakespeare. 'My idea,' he wrote on 23 April 1866, 'is that the Shakespeare—which I mean to make my masterpiece—should contain a large number of plates. My idea would be to announce a work with 1000 drawings—not too many for such a vast theme. Moreover the number 1000 is round and sonorous and would produce a fine effect in advertisements and posters.' Here sounds the very voice of bad nineteenth-century art—the ring of high ambition blended with the hollow boom of salesmanship.

For Doré the two goals split awkwardly into rivals; the illustrations sold like hot cakes but the paintings were consistent failures. His entries for the 1867 Salon included two vast canvasses labelled, not very originally, 'War' and 'Peace' and also a minutely studied scene called 'The Neophyte', showing a young monk tortured with second thoughts after taking his vows (Doré was so taken with it that he etched it nine times).

They were poorly received as usual, but he was busy at work on another of his 'master-works', *The Fables of La Fontaine*, for his old publisher Hachette. He found it uphill work: 'the job appalled me, crushed me,' he admitted.[35] Handsomely produced in his favourite folio format, it was criticised by experts,[36] but became so popular that a cheap 50 centime serial edition appeared two years later.

Another balm to his bruised pride must have been a letter from Victor Hugo, doyen of French literature. Doré had made two small drawings for an English edition of his *Travailleurs de la Mer*.[37] He seems to have planned a de luxe volume with many illustrations and may have sent the poet a sample page, for he received an enthusiastic letter of thanks, in which Hugo, addressing him as 'Jeune et puissant maître!' rejoiced that he could furnish 'the occasion for another monument'.[38] An even more solid prop for his self-esteem came in the form of an official invitation to accompany the Empress on a trip to Suez. Presumably some return in the way of publicity-provoking drawings was expected. But Doré, who felt less and less happy the further away he was from the maternal bedroom, refused.

But he could no longer put off a visit to the mysterious fog-bound land which he knew from Dickens and Cruickshank and descriptions by anglophiles like Gautier, and where he was already so much admired. Encouraged by a rather improbable new friend, a minor canon of Westminster called Frederick Harford (we are a long way now from high jinks with Dalloz or de Nerval), he set sail at last, arriving at the Grosvenor Hotel in Victoria Station on 18 May 1868.

From the start the visit was a success. His publishers had smoothed the way, and already a one-man show of his work was at the Egyptian Gallery in Piccadilly.[39] This was a popular establishment with plenty of wall space, and the centrepiece, which had appeared in the Paris Salon the year before was an enormous painting called 'La Table Verte'—it represented the gaming-table at Baden-Baden in full fashionable swing, one of those decorously wicked scenes the Victorians loved.

Doré, who in Paris had always circled on the artistic and social fringe, was a lion here. He was wined and dined and fêted, whipped off to races and cricket matches, entertained in exclusive clubs, official balls and aristocratic houses. Staunch loyalist as he seems now to have become,[40] he found time to call on the Comte de Paris at Twickenham, made the acquaintance of the Prince of Wales and was introduced to the queen.

35 Jules Claretie
36 'La Fontaine sees clearly and true: M. Doré sees falsely, strangely and eccentrically,' wrote a critic. See J. Claretie
37 Blanche Roosevelt speaks mistakenly of 300 sketches.
38 Letter of 8 Oct 1866
39 It had been organised by a Parisian friend, M Arymar. The gallery had been chosen by Benjamin Haydon to display his vast but unfortunate canvases and had recently housed 'an exquisite model in rice paste of the Death of Voltaire'. See the *Sunday Times Colour Supplement*, 19 Mar 1972
40 In spite of his intimacy with the Emperor, which had been sealed by the gift of a diamond-tipped pencil. See G. F. Hartlaub, *Gustave Doré*, 1930

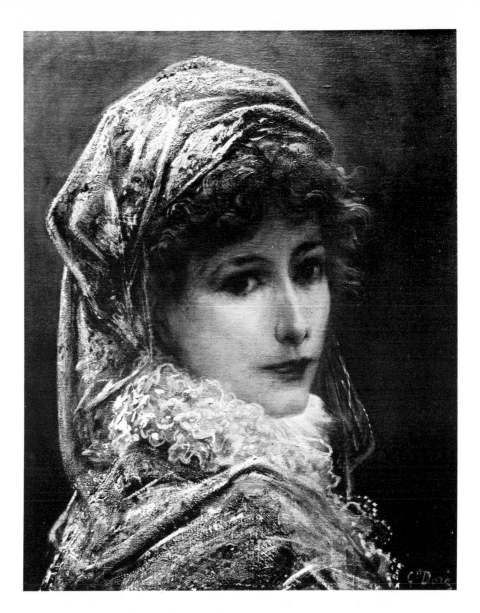

*Sarah Bernhardt. Oil, undated*

London encouraged all too readily the new sanctimonious streak in his character. He went so far as to sign a letter to the canon: 'Gustave Doré, chrétien militant!' and rapidly earned the title of the 'painter-preacher'. He basked and expanded in his popularity and must have been almost loath to sail for home. After a holiday in Switzerland with his mother and Kratz, he returned to Paris. But things were not as they used to be there, and now a new blow struck him. On 13 November Rossini died, and it fell to Doré to make the customary deathbed drawing of the corpse. He made two sketches, and from one of them engraved a widely distributed etching.[41]

Rossini's death symbolised the end of Doré's happy days in Paris, and virtually the end also of his career in France. He went on churning out huge canvases from his enormous studio (it had formerly been the Amores gymnasium) with its tapestries and busts and its grand piano. But it was becoming more and more of a struggle; the studio has rightly been described as 'the scene of Doré's battle against his own talent and his own fame'.[42] He added sixty plates to his Dante, illustrating *Purgatory* and *Paradise*, but they were very far below his earlier standards. He completed his Tennyson *Idylls of the King* series with

[41] The drawing for the etching—now in the Musée Carnavalet in Paris—shows a Dantesque profile with a wreath tactfully replacing the wig which the composer wore against the cold, sometimes putting two or three over each other. See Herbert Weinstock

[42] Konrad Farner, *Gustave Doré, der Industrialierte Romantiker*, 1963

*Enid.* But 1869 was virtually blank so far as illustration was concerned. His Salon exhibits—now annual—were annually overlooked. The centre of his activities had become London.

This fact was symbolised, both as regards to prestige and to profit by a remarkable phenomenon—the Doré Gallery.[43] As far back as 1867 the London publishers Fowler and Beeforth had commissioned from Doré, for £800, a large 'highly finished' painting of 'The Fall of Paganism' plus some other edifying pictures; they were to own all rights to the works. During his first visit these had been exhibited (17 April to 26 September) at the German Gallery, 168 New Bond St. The next year, in 1869, they took over the Basilwood Gallery, which provided larger premises constructed out of what had formerly been the Black Horse Hotel, at number 35. Here over twenty-three years, more than 2½ million people paid a shilling to see paintings by Doré (the artist received 15 per cent on sales) until they were finally shipped to America in 1892.[44]

Thereafter the gallery, though still bearing his name, was used for a variety of exhibitions. The one which would have upset him most was in 1912 when, for a few hectic weeks, the Italian Futurists took over the premises and society ladies fluttered round Signor Marinetti's construction of handkerchiefs and tin cans.[45] More to his taste would have been the ultimate fate of the gallery, which emerged after the Great War as the salerooms of Messrs Sotheby, a shrine of the double-headed god of art and commerce.

These two facets of Doré's work were evident in his exhibits, which were vast, pious and badly painted. Sometimes they were refugees from Paris Salons, where, as a 'decorated artist', he had the right, often exercised, of submitting pictures at the last moment—only to see them neglected. They were also very expensive. His 'Christ leaving the Praetorium', a painting measuring 30ft by 20ft, sold for £6,000; the queen laid out a more modest £400 for a scene of a youth playing the lute. Many of the works were commissioned by Messrs Beeforth and Fairless; Doré received 15 per cent on sales, and altogether received £60,000 from them. This was a huge sum at that time, making Doré— who is reputed also to have earned 7 million francs for his illustrations between 1850 and 1870—one of the richest artists of his time.

One of Doré's London acquaintances was a journalist whom he had met thirteen years earlier when he had been commissioned[46] to illustrate a visit by the British queen to Boulogne. His name was Blanchard Jerrold, son of the writer Douglas Jerrold. Doré must have seen him during his first visit to London, for on his return the next summer (perhaps to supervise the production of a huge double-decker volume devoted to his gallery)[47] he stayed with him in Jermyn St. Evidently they talked business, for one day Doré's clergyman friend received a hasty note from the chief of the police: 'Dear Sir, I regret that I have only just heard of Monsieur Gustave Doré's wish to see the dens of the London thieves tonight. There is no time now to make proper arrangements, but you may be put in the way of seeing a good deal by showing this note to the inspector on duty at the King St police station. Yours faithfully, Thos. Peirson.'

The excursion was Jerrold's idea and was part of a master-plan. He had conceived the idea of a vast compendium, 'in the wake of Leigh Hunt and Charles Lamb' showing every side of London life. Starting

[43] It may have been inspired by the example of the Thorwaldsen Museum in Copenhagen and the Wiertz Gallery in Brussels. See Hartlaub

[44] In this year they were exhibited at the Carnegie Hall in New York as 'the greatest collection of religious pictures in the world'. The London dealer, who had paid 300,000 dollars for them, then put them in store with the Manhattan Storage Co; on non-payment of rent they were auctioned, but the highest offer was only 12,000 dollars and they were returned to store. On 31 July 1964 twenty-two of them were sold at Christie's in London—making only £800.

[45] In 1915 it was the scene of the only exhibition of the English Vorticists.

[46] By Sir Robert Ingrams for *The Illustrated News* in 1855

[47] Edmond Ollier, *The Doré Gallery,* 1871

with the arrival up the estuary so much admired by Gautier, the imaginary visitor was to be conducted through dockland, past Westminster, and up to Putney and the boat-race stretch of the river. From there he could switch naturally to Epsom and the Derby and the entertainment areas in the West End, with forays into specialised areas like the opera house or a brewery.

Accompanied, at first, it seems, by the canon and shadowed by Sergeant Meiklejohn of the detective service to protect them from potentially hostile gin-sodden crowds, the curious couple set off on their rounds, notebooks in hand. Proceeding 'as pilgrims, not historians'[48] they wandered over the city, penetrating into districts probably even Jerrold found surprising, and opening up to Doré sights he had not seen since his first youthful studies of the Paris poor. The lives of the rich were the same everywhere, and inspired only conventional responses; but the London slums were something special; their depths were like Dante's pit to him. *The Inferno* had brought out the best of his youth, and now, fat, flourishing and pushing forty, he suddenly found in this new hell a new inspiration.

Returning home to work up his notes, which he developed into an enormous album to impress publishers,[49] he passed a few weeks with Kratz in his beloved Vosges and found himself back in a Paris on the brink of war with Prussia. With disaster looming, he had to cancel a proposed return-trip to London and soon France was under attack and the capital itself besieged. Canon Harford rallied round by sending over 'a silver flask of a peculiar kind, one which can be drunk from without using both hands.' 'I shall carry the flask with me to the ramparts,' wrote the artist in return;[50] he did in fact enrol as a *garde national*.

As a simple, uncomplicated patriot his country's defeat depressed him deeply and he was particularly upset by the cession of Alsace to Germany, in spite of a gallant defence of his native Strasbourg during which his brother Emile had been decorated. He responded with a shower of patriotic but ill-favoured paintings and drawings. The revolutionary upheavals which followed defeat evidently disturbed him equally, for he moved out of Paris with his mother to stay with some friends, M and Mme Braun, in the legitimist stronghold of Versailles.[51] Here he made some prosaic wartime illustrations of the fighting; but his unique spark was not quite extinguished and he followed this up by some brilliant caricatures of Thiers and his followers and some rather more respectful ones of the rough champions of the rebellious Commune, besides a characteristically vigorous series of the German generals, an easy prey to his devastating pen.[52]

Meanwhile he was working on his *London* project. At one moment he so lost heart that he tried to get out of the contract; but eventually he returned to England, taking with him as a precaution an artist friend, M Bourdelin, whom he hoped would help him with some of the architecture in the proposed 200 drawings. This time he set up a studio in a large flat in the Westminster Palace Hotel.[53] Here he stayed for six months—a very long and thorough visit for him—during which he and Jerrold scoured the city, with two detectives always in tow. By day he was a celebrity, attending social functions and visited by the Prince of Wales; at night he slipped into old clothes and pushed into stinking alleys and dark pubs. He visited Tiger Bay and the opium den described by Dickens,[54] sketched the lay-reader in the Field Lane Refuge, and met

48  Blanchard Jerrold, *Gustave Doré*, 1891
49  His family's first view of it was the occasion of a violent row with his brother Ernest. He later demolished the album and is said to have distributed the drawings as gifts.
50  Letter of 13 Sept 1870, quoted in B. Roosevelt
51  He repaid their hospitality with a childhood album. See Catalogue Introduction by A. Mercier to an exhibition at the Musée de l'Ain, Bourg, in 1965
52  The parliamentary cartoons were to lie unpublished until 1907, when they appeared as *Paris and Versailles in 1871*. The series of German generals, still owned by the artist's family, have not yet been published.
53  He had arrived first at Morley's Hotel on 10 July, according to Jerrold.
54  In *Edwin Drood*

'the strongest woman in Shadwell.[55]

On his return home he used his new knowledge of the English for a satirical volume in his youthful style called *A Cockayne in Paris*, but now he had a new passion—sculpture. Hoping to win from it the acclaim which had always eluded his painting, he began to experiment, unaided, behind a screen in his studio. It was something of a refuge. Paris was no longer the playground of his youth. Dumas was dead and now Gautier, his health broken by the siege, died too. His brother Ernest was sick—or at least behaving imprudently ('I am very much afraid that he is threatened with a serious brain disorder') and his aging mother had become a chronic sufferer from bronchitis, to which he too had become prone since the hardships of 1870. There were no more noisy parties in the rue St Dominique.

Escaping from domestic cares and the post-war sobriety of Paris, he was in London again in 1873. The big book had safely come out the previous year to the usual public approval. He had fallen out with Jerrold (who was understandably annoyed when Doré agreed to a new text, by Louis Enault, for the French edition) but he had his old friend Harford and he had also become intimate with one of the prince's aides, Col Teesdale,[56] who invited him to Scotland. They travelled by sea, setting off from London on a ship bound for Aberdeen, a trip which left Doré unable to appreciate even the beauties of the drive from Ballater to Braemar.[57] But soon he was busy with notebook and brush, practising his violin (in imitation reels) and unskilfully plying a salmon rod. The wild scenery was much to his taste. He made many landscapes of it, and returned the next year for more material.

In 1873 he added his old Rabelais to his de luxe editions, bringing out a splendidly printed volume with sixty additional drawings, and undertook a trip round Spain with Charles Duvillier in an attempt to capture the spirit of his youthful travels with Gautier and Dalloz. Almost the whole of 1874 was devoted to painting, but the next year brought—without warning—another flash of inspiration. He became obsessed by Coleridge's *Ancient Mariner*, and the result became his last real monument—an undoubted artistic success, however unrewarding commercially.

The business failure of this venture hurt his pride as well as his pocket. The summit to which he aspired was still beyond his grasp and he was no longer young. 'This evening Doré turned up chez Sichel,' wrote the Goncourts in 1877.[58] 'He has grown stout and thick, and out of this fat boy come high-flown aesthetic talk and vague theories which make him sound like a drover with a touch of mysticism.'

But he had great hopes for his sculpture. In 1877 he finally exhibited a sculptural group in the Salon, characteristically labelled, 'Love and Fate'. Next year he showed 'La Gloire' and carried out a figure representing 'La Danse' for Garnier's new opera house in Monte Carlo.[59] His taste was uncertain to say the least. In 1882 he showed in the Salon a gigantic vase encrusted with writhing figures called 'Poème de la Vigne' which was dubbed by the Goncourts a 'holy bottle'.[60] But his modelling skill was remarkable, a reminder of the sense of volume which marked all his best work after his Rabelais. Two at least of his groups, a pyramid of nine acrobats and a St George perched aloft on his own lance, show real inventive flair; but his handling and style remained deeply conventional.

[55] His eye was not distracted by chat, for his only English was a current popular song, which he rendered: 'O vere, O vere eez my leetle tog gone?'
[56] Together with Harford, he was one of the friends invited in Doré's will to choose a memento. The others were Jules Girardin, son of the publisher, and the engravers Leleux and Pisan. His closest friend, Arthur Kratz, was not mentioned, presumably because he had had many personal gifts already, and was in no need of money.
[57] B. Roosevelt
[58] *Journal* of 1 Sept 1877
[59] The companion, 'Musique', was entrusted to Sarah Bernhardt, who had taken sculpture lessons with Doré. She later had her own studio in the Boulevard de Clichy.
[60] Now in San Francisco. A companion piece was destroyed by shelling in Reims in 1917.

*Saintine*, Le Chemin des Ecoliers, *1861*

Good fortune ordained that his only public sculpture is much his best. After the death of Alexandre Dumas in 1870 he was commissioned to design the memorial. It was still in the foundry at Doré's death, but official recognition must have brought enormous pleasure to him.

Meanwhile he found time and energy to add a last contribution to his 'roll of honour'. In 1879 another huge volume came out from his old publisher Hachette, its cover gleaming with scarlet and gold. Ariosto's *Roland Furieux* (Orlando Furioso) contained no fewer than 618 drawings, many of them full folio size and of undiminished verve. He even bought an expensive site near the Parc Monceau for a vast new studio.

But this was to be his last effort. His mother, whom he had tended for two years, was failing and on 16 March 1881 Doré wrote to his old friend Harford: '6 am. Dear Friend, She is no more. I am alone . . . You are a priest, dear friend, I conjure you to send up all your prayers for the repose of her dear and sainted soul, and for the sustenance of my own reason; for I am strangely overcome by despair, discouragement and fear for the future.'

Doré's own health was bad. He suffered from attacks of asthma and had had a mild heart attack the previous year.[61] He complained of feelings of suffocation and his spirits drooped. The old singing and dancing was gone, the cafés shut and their habitués grown old. His studio servant, Jean, was dead. Only old family friends like Mme Braun and the faithful servant she had passed on to Mme Doré, Françoise, remained to look after him. He worked away at illustrations for his great Shakespeare project, starting successfully with *Macbeth* (witches and murder were always sympathetic subjects) and carried out some uncertain but prophetic drawings for Poe's *The Raven*. The sinister black bird had come home to roost, and the word 'nevermore' hung in the air.[62]

He still kept up appearances of high spirits in public but in the last days of the year he was writing to Harford: 'I pass entire days without any exchange of friendly words, and foresee that on Sunday, New Year's Day, I shall perhaps be the only soul in Paris dining alone. Everybody I know has a family . . . I have been wrong to let myself slide on into my present age without having established a home and hearth for myself.'[63]

[61]  See A. Mercier
[62]  See the Goncourts' *Journal* of 10 Feb 1880
[63]  30 Dec 1881

29

It was too late now. His mother had been his first and last true love and she was gone. He was lonely, ill and disenchanted. If he had only known it, an obscure little painter in Holland was fighting on his side: 'Of course I too can see the difference between a drawing by Doré and one by Millet,' wrote Van Gogh in October 1882, 'but the one does not exclude the other. There is a difference, but there is also a resemblance. Doré can model a torso and put the joints together infinitely better than many who revile him with pedantic self-conceit . . . I say that if somebody like Millet had criticised Doré's drawing—I doubt if he would, but suppose he had—well, then he would have had the *right* to do so; but when those, who cannot do with their ten fingers a tenth of what Doré can do with one, revile his work, then it's nothing but humbug.'[64]

The worlds of Doré and Van Gogh lay far apart (would a certain innocent earnestness have made a bond?) and on the following New Year's Eve he is more likely to have read a forecast in a Paris paper: 'Next year M Gustave Doré will continue to make crazy paintings and boring sculpture.'[65] That night, after a quiet dinner with Kratz, tears of self-pity began to run down his cheeks and 'he began to speak on several subjects of too private a nature to find any place in this recital', as his biographer Blanche Roosevelt recorded tantalisingly.

Two weeks later he had recovered enough to give one of his Sunday dinners. The guests were his childhood friend Dr Robin, one of his engravers, Paul Joanne, and the faithful Kratz.

Doré had decorated the table with white mortuary flowers and entertained his friends with a parody of a funeral oration. At a dinner party the next Saturday where he was expected, he failed to turn up. Eventually a formal note arrived, signed by his valet and regretting that he was indisposed. After dinner Kratz found a telegram waiting for him at home. It was from Dr Robin. 'Come at once. Gustave is ill, apoplectic fit. Very serious.'

He had risen at seven as usual and gone into his studio. Feeling ill he returned to the bedroom where the listening Françoise heard a crash. He had fainted and fallen. With the help of the valet, Martin, he was carried to bed and the local doctor was summoned. But his condition grew worse and he felt he was dying. 'I want Kratz,' he said 'Him you may tell, but nobody else.'

It was midnight before Kratz arrived. Doré was better and next morning saw two old engraver friends, Pisan and Leleux, and began fussing about the casting of the Dumas memorial. The next day he was strong enough to have a glass of champagne and his brother Emile who happened to be in Paris, looked in. Giving Françoise the chance to get some rest, he took a turn at the bedside. Soon after midnight, Doré suddenly gasped and turned pale. In a moment he was dead. It was Monday, 21 January, and he was fifty-one. The doctor recorded that he had died at 1 am of angina, 'a common complaint of asthmatics'.[66]

He died a rich man, leaving 713,000 francs.[67] Everything was to go to his bachelor brother Emile and then to two orphanages and the Society of Arts.[68] Three days later the mourners gathered in the rue St Dominique for the funeral. The Goncourts were there. 'A huge room with a pale panelling and green curtains and a provincial chandelier. Through a crack in the drawn curtains a slit of sunlight falls in Rembrandtesque style on the skulls of a row of pale yellow figures, and lights up a terrible Alpine landscape painted with the colours of decomposition. It is a

[64] In a letter of Oct 1882 to Anthon van Rappard

[65] J. Claretie

[66] The declaration is signed by Dr Blanche, perhaps the same doctor who attended the dead de Nerval. Afterwards there was gossip that he had arrived late and administered too much opium.

[67] Of this sum the Parc Monceau site contributed 400,000fr. His paintings were valued at 71,000fr and the one third share of the house in rue St Dominique at 56,000fr.

[68] He had fallen out with his brother Ernest, who had lost money on the Stock Exchange and probbly tried to touch him for help.

supremely bourgeois salon where the friends and acquaintances of Doré have gathered to accompany him to the cemetery.'[69]

They included, besides the family and intimate friends, Dumas *fils*, Leo Delibes, Jules Ferry, Nadar and many of his engravers. The service was at Ste Clothilde, and he was buried beside his mother in the Père Lachaise cemetery. Dumas gave an oration which skilfully suggested that Doré had sacrificed his life in his labours on the monument of his father, and praised his work: 'What rapidity! What originality. What an inexhaustibly far ranging imagination! What a miraculous knowledge of cause and effect. What a world of gods and goddesses, saints, martyrs, apostles, virgins, archangels, heroes, giants, fairies, celestial and monstrous spectres, divine and droll, take on birth, form, colour and movement in this luminous brain!'

Allowing for the demands of the occasion (which must have dictated the delicately descending scale of fantastic creatures) there was much truth in Dumas's exclamations. Within his limits Doré had several times proved a master. An innocent, rather touching immaturity, symptom of the 'Muttermensch', denied him full artistic stature but gave him his vitality, his inventive imagination and his simple ambitions. His surname, 'Gilded', proved all too apt: the golden boy turned too often into a pinchbeck star. But his talent kept its fitful gleams to the last, and his touchingly human nature never hardened. 'In the painter's youth,' continued the Goncourt *Journal*, 'I found him insufferable. Later, and above all in recent years when I used to dine with him chez Sichel, I discovered under the crude and clumsy exterior a decent old boy.' The 'gamin de génie' had grown into a 'loyal garçon', a true and amazing child of his time.

[69] *Journal*, 25 Jan 1883

32

# WORK

## SATIRE

Doré's artistic output—which he contrived to superimpose, in the fashion of his day, on a cigar-and-champagne social life—was nothing short of prodigious. Apart from inborn dexterity,[70] he had an ever-gushing imagination. 'If you presented him with a subject like the influence of the flea on female sentimentality he would come up with 500 illustrations,' remarked Gautier.[71] Whatever the force which drove

*Rabelais,* Gargantua and Panta-gruel, *1854*

(facing page)
La Ménagerie Parisienne, *1854*

[70] His facility and speed were famous. On 20 March 1863, the Goncourts wrote in their *Journal* of the artist Gérard 'doing a Doré' by drying his watercolour over a lamp.
[71] J. Valmy-Baysse

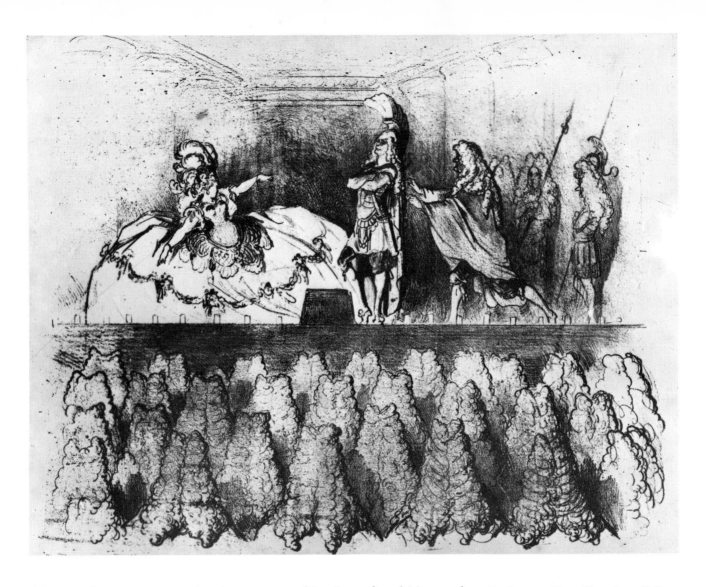

*Racine at Versailles*, Les Folies Gauloises, *1859*

him—and we can guess that it was a combination of ambition and nervous energy—the results were enough for three careers. Teaching himself the technique in his last decade, he immediately turned out fifty-six pieces of highly wrought sculpture: he produced over a hundred paintings, popular enough at the time to keep a one-man show going for twenty years, and these were on top of the graphic work which formed his main career. Over about thirty years he illustrated 221 books, some of them with 400 or 500 drawings; did 105 lithographs and etchings; 283 watercolours; and 526 original drawings. His total graphic output amounted to 10,825 works.[72]

In such a flood there was inevitably much second-rate stuff and much repetition, not only of images but of moods. The recurrence of these—satire, adventure, horror, awe, realism, compassion—offers a convenient framework in which to examine his general approach, especially as they developed (with frequent flashbacks) more or less in step with his life.

It is not surprising that satire was his first, and perhaps most recurring, field. Psychology teaches us that teasing is a form of aggression, and we know children are aggressive. Doré, a Peter Pan of the pencil, was no exception. But his first onslaughts were as playful and harmless as the pats of a kitten. His childhood cartoon-albums are enchanting, with

[72] Figures taken from H. Leblanc. Hartlaub writes of '40,000 drawings before he was 30.'

34

their little Grandville-style animal figures and light-hearted text. This good-tempered mockery—what a contemporary, Arsène Houssaye, called 'the banter which flashes through the French genius'—exactly suited Doré's first editor Philipon, who had got into hot water over Daumier's cartoons and wanted no more trouble. Doré was not and never would be, a social protester, and the speed and invention which the *Journal pour Rire* demanded were just what he could provide most easily. His teasing remained on an endearing schoolboy level, 'not so much satirical as cheeky'.[73] He poked fun at foibles and fashions but not at basic beliefs; he laughed at the means but he took the ends as natural and inevitable.

A child's pencil or pen was all that he needed. His sketches were translated by professional craftsmen, first into lithographs and later,

(both illustrations)
*Balzac,* Contes Drolatiques, *1855*

73 J. Valmy-Baysse

after the first thirty-two numbers of the journal, into wood-engravings. This method (Bewick's cross-grain technique had been introduced into French journalism in the *Magasin Pittoresque* in 1833)[74] gave sharp but rather crude results, for which Doré adapted the emphatic style of colleagues like Cham and Bartell and Traviès, with straight linear hatching and strongly caricatured figures. He soon learned to draw direct into the wood-block—a method he was to stick to for twenty years, even after he had deserted an inked line for shadowy wash effects.

His captions were not brilliant, but his droll drawings (sometimes he and Nadar worked on them together) had a huge success, tilting at familiar but harmless targets like lawyers and doctors. His natural high spirits exploded in a lifelong series of cartoons and good-natured

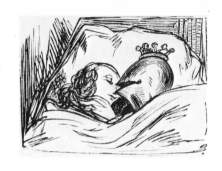

(both illustrations)
*Balzac*, Contes Drolatiques, *1855*

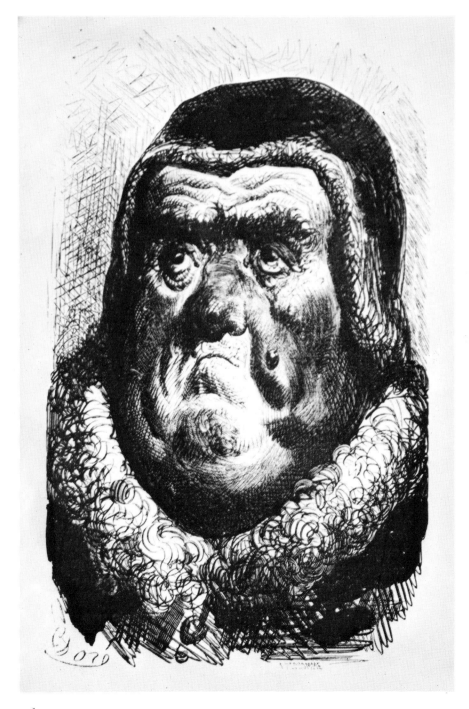

74  J. Valmy-Baysse

*Caricature of Thiers,* Paris et Versailles, *1871*

37

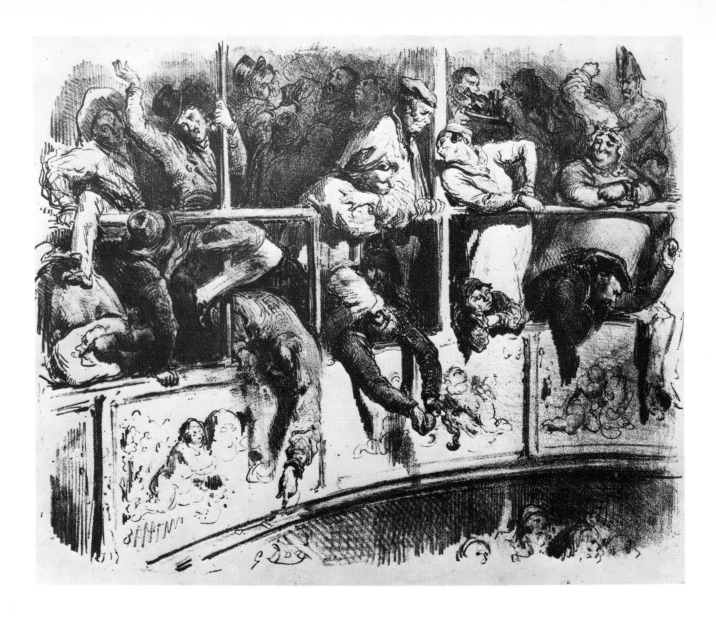

frolics, from the scintillating *Hercules* of his teens and *Trois Artistes*, to
the masterly lithographed skits on Paris life, *La Ménagerie Parisienne* and
*Les Différents Publics de Paris* (which combined the toughness of
Daumier with the elegance of Guys or Gavarni), from the *Folies
Gauloises* historical lithographs to *Le Roi des Montagnes*, *Le Chemin des
Ecoliers*, *Capitaine Castagnette* and *Baron Münchhausen*. Even his vigor-
ously nationalistic *Russie* and his 1870 caricatures of the Thiers govern-
ment and the victorious German generals are mocking rather than
vicious.

It was the same lively sense of fun which inspired his play with the
medium. The technical pace of *Russie* is tremendous, and artfully
planned, right down to the last pictures with their surprise note of
sympathy for the Russian troops. When Doré fills in a tedious epoch
with a set of differently shaped blank squares or renders the disordered
and unmentionable reign of Ivan the Terrible with a shapeless black
blotch, he is jumping forward a hundred years. No wonder that this
book has been claimed as an ancestor of the modern strip-cartoon.

The element of exaggeration which lies at the root of satire turned
with Doré into a grotesqueness which betrays his cultural background.

Les Différents Publics de Paris,
*1854*

38

*Ariosto,* Roland Furieux, *1879*

*Cervantes,* Don Quixote, *1863*

The Strasbourg in which he spent his boyhood was still very Germanic. Apart from the gabled roofs and twisting, narrow streets which appear again and again in his work—sometimes, as in his Rabelais, rather incongruously—the city was still mainly German-speaking. Even by 1870 only one young Strasbourgeois in three could speak French,[75] and Doré, whose family name had, according to one writer,[76] originally been 'Dorer', a variant of Dürer, must almost certainly have been bilingual as a child.

The result was a unique mixture of neo-gothic and neo-rococo, with a boisterous humour which separates him clearly from the delicate fancies of Grandville and the elegance of Gavarni (the Swiss Toepffer was a stronger influence). Even Daumier's pen is less brutal, though often more effective. Though Doré could temper his line on occasion, for his *Fables* of La Fontaine for example, it is Bosch and Bruegel who are recalled in his pot-bellied monks and stringy knights, not Callot or Fragonard.

This almost coarse frontal approach gave him the key to his first big success, a vision of the Middle Ages when France was still unaffected by the civilising airs of Italy. Rabelais's sense of fun was earthy, and

[75] de Lamirault, *Grande Encyclopédie*, 1903. A drawing by Doré of 1865 is captioned in his handwriting in German. See illustration 'The Scrap Merchant'
[76] Millicent Rose, *Gustave Doré*, 1946

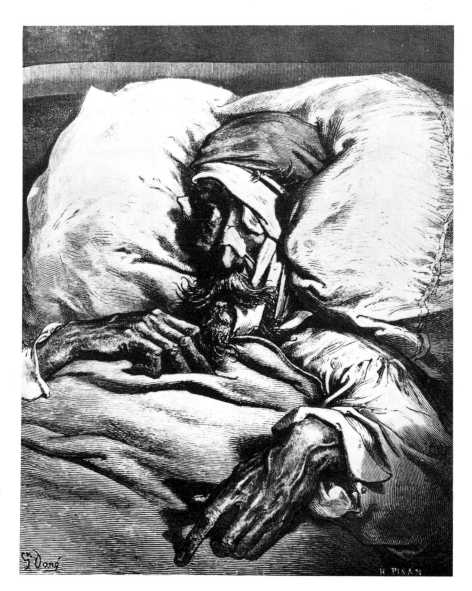

(facing page)
*Théophile Gautier,* Capitaine Fra-
casse, *1866*

La Ménagerie Parisienne, *1854*

proved a perfect match for Doré's bounding and plunging fancies which were still rooted in the schoolroom—though we can see how the full-blooded narrative gives birth in Doré to a new rounded style of modelling and a new sense of hollow space. Unfortunately the first edition of *Gargantua and Pantagruel* was abominably printed on horrible paper, and many of the qualities of the drawings remained hidden until the lavish 1873 edition.

As a sequel Balzac offered the same rumbustious opportunities,

(facing page)
'*Portrait of Lord Seymour*', *probably about 1871*

*La Fontaine, Fables, 1867*

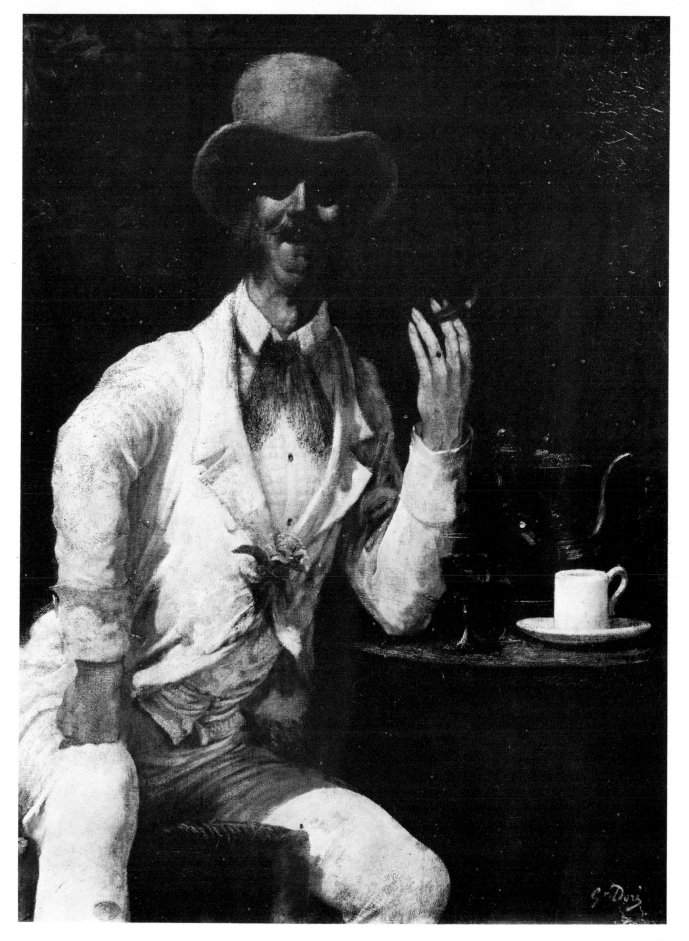

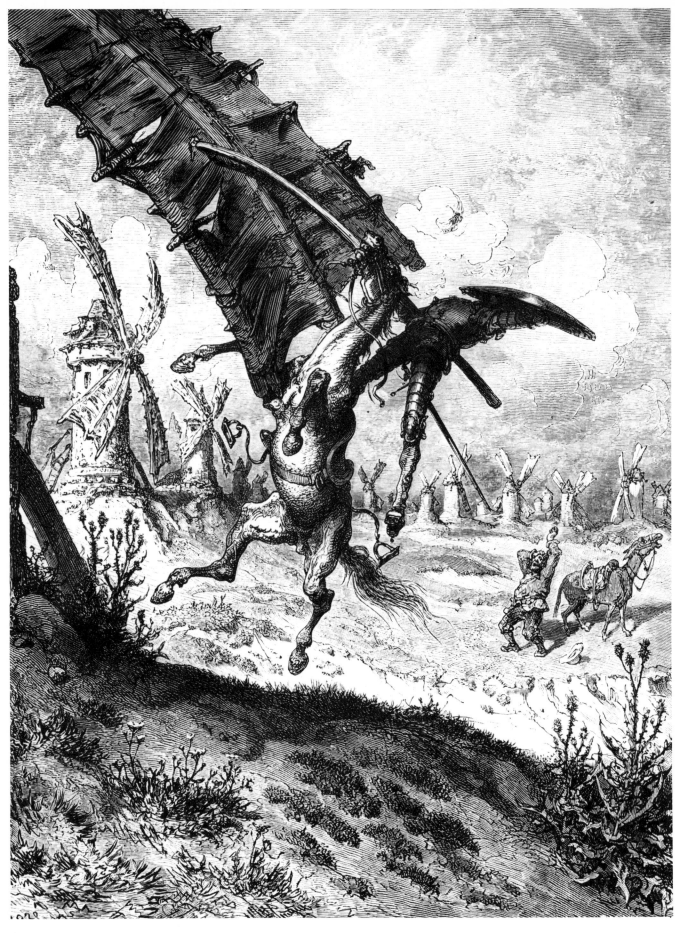

'*The Scrap Merchant*'. *Chalk, about 1865*

(facing page)
*Cervantes*, Don Quixote, *1863*

though here—perhaps partly because the format was small and the printing again poor—the drawings are simpler, with a black-and-white melodrama sometimes verging on the crude.[77] However a new sense of what we should now call Expressionism was creeping into Doré's style, giving a macabre and distinctly nordic edge to his satire. Even the extraordinary set of portrait heads for his Balzac and Rabelais—as round and ominous as turnips—have the quality of a bad dream, a child's nightmare which was to surface more openly in figures like the monsters in his Ariosto, and to swell into visions of spiritual as well as physical suffering.

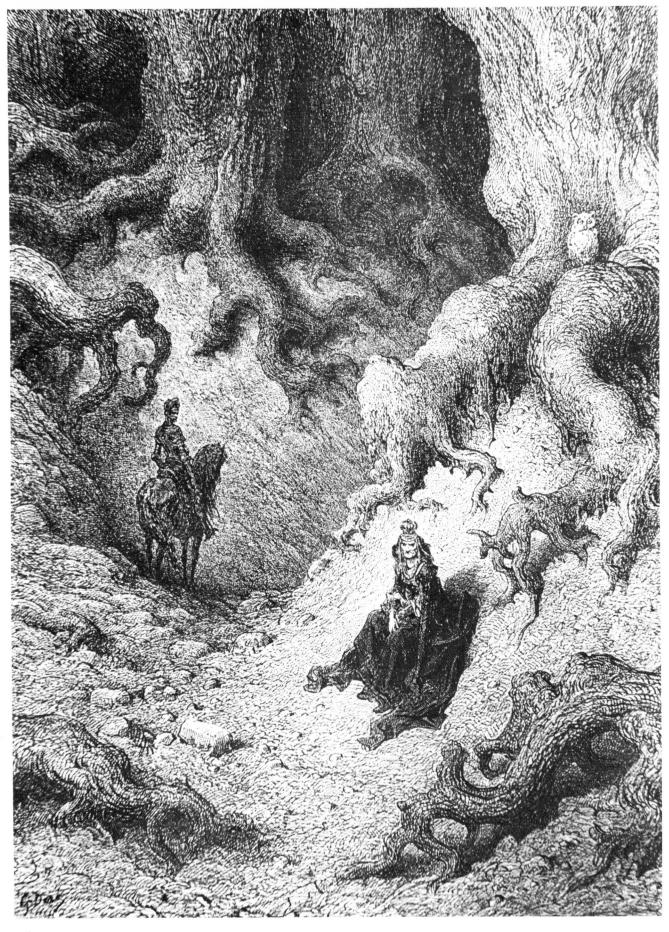

# ADVENTURE

A sense of fun is first cousin to a sense of adventure; both are marked by a quality which was one of Doré's greatest gifts, a feeling for movement. He liked to work on several drawings at once (a painter friend described him with twenty, passing rapidly from one to the other) and he himself was a bustling little man. He loved to dance and swim and perform tricks on his trapeze, and his slightly bulging blue eyes were as quick to grasp a characteristic movement as his hand was to record it. Even in his childhood sketches the sense of action is strong; one has only to look at the lion whizzing into a spiral, flung from Hercules's whirling arm.

It was this sense of motion which gave life not only to his figures in the *Journal pour Rire*, but to the way he laid them out on the page (especially effective in his *Russie*). Muscular effort and energy always fascinated him. We can trace the obsession from the caricatures of a

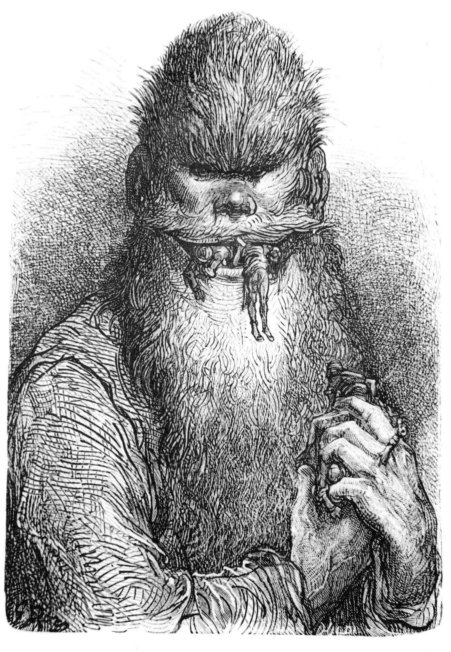

(both illustrations)
*Ariosto,* Roland Furieux, *1879*

47

*Ariosto*, Roland Furieux, *1879*

(facing page)
*'Rotten Row, London'. Wash and Ink, 1873*

ballet-dancer done for Philipon to the writhing giants in *The Inferno*; in the swirling crowds in his Rabelais as much as in the dull tread of the prisoners in Newgate gaol who so impressed Van Gogh.[78]

Nineteenth-century admiration for pioneering and enterprise gave a boost to tales of picaresque adventure, the kind of story so well exploited by Dumas (to whom Doré had been introduced by his school-friend Paul Dalloz and with whom he struck up a friendship based on mutual esteem). The sensitivity with which Doré responded to an author can be judged by comparing his renderings of these extrovert adventures with the resonantly romantic exploits of Tennyson a generation later.

It was probably the picturesque element, plus the note of sustained mockery, which drew him to Cervantes, and in *Don Quixote* his narrative élan appears at its best. He had studied the subject at length—he must have had it in mind when he first visited Spain with Gautier and Dalloz in 1855—and he developed his memories and notes eight years later (incongruously, mostly at Baden-Baden) into 377 illustrations of unequalled verve and variety. The range of invention stretches from scenes of emotional intensity, such as Sancho Panza embracing his ass, to boisterous incidents like the Don whirled up by a windmill, spreadeagled on the ground, or waving his naked legs in the mountain air. The variety is held together, as in his Rabelais (which

[78] His painting, copied from Doré's engraving, is now in the Pushkin Museum in Moscow. 'It is very difficult,' he wrote to his brother Theo in Feb 1890.

*Rabelais*, Gargantua and Pantagruel, *1854*

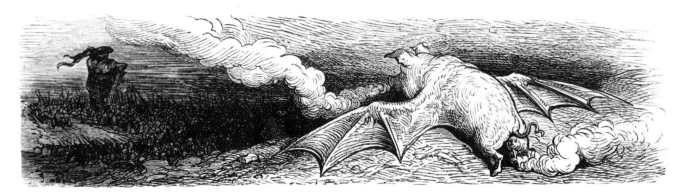

G. Doré

23 juillet 73

49

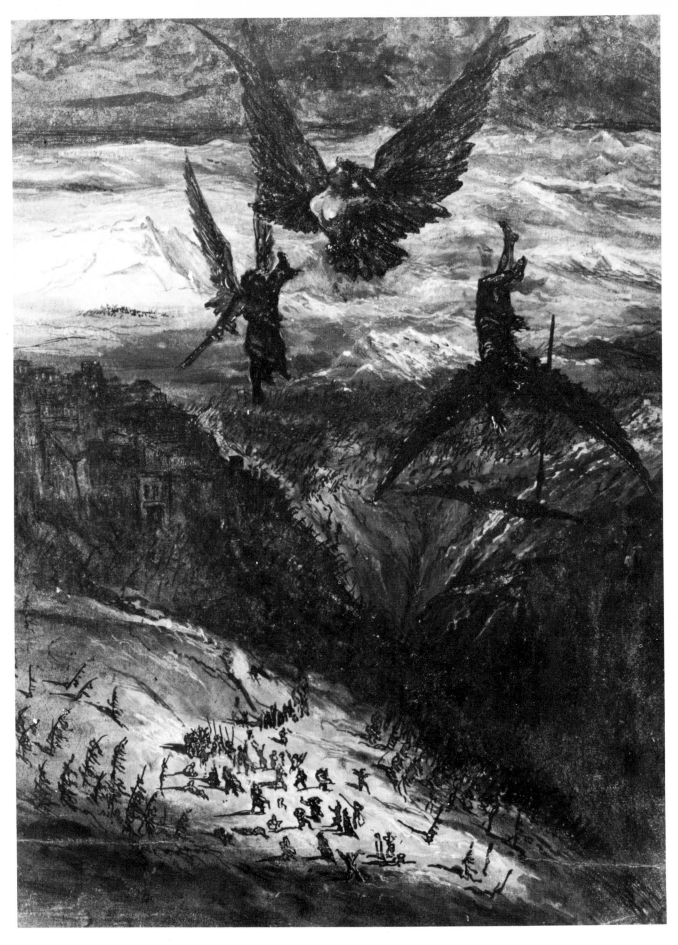

(facing page)
*'Fall of the Rebel Angels'. Wash and Ink, undated*

*Cervantes,* Don Quixote, *1863*

79   He was one of those designated in Doré's will to choose a memento.
80   Harold P. Vincent, *Daumier and His World,* 1968

was cut by Sotain) by the use of a single engraver. This was his favourite Heliodore Pisan, a Marseillais who was to remain an intimate friend.[79]

The book was in the air. It had been illustrated by many artists in several countries (though never, oddly, in Spain); Hogarth and Cruikshank had tackled it in England. In France there had been a number of editions, including a cheap and popular—though feeble—version by Tony Johannot; in most of these the Don looks like an emaciated colonel with a fierce moustache. Daumier had done an engraving on the subject for *Charivari* as early as 1839, and sent a painting of Don Quixote to the Salon of 1850. But somehow Doré's interpretation annihilated all previous efforts and gave the myth a new life. It 'encouraged Daumier to produce some of his finest paintings'[80] and it fired Zola, who was just then being introduced into the world of

*Cervantes,* Don Quixote, *1863*

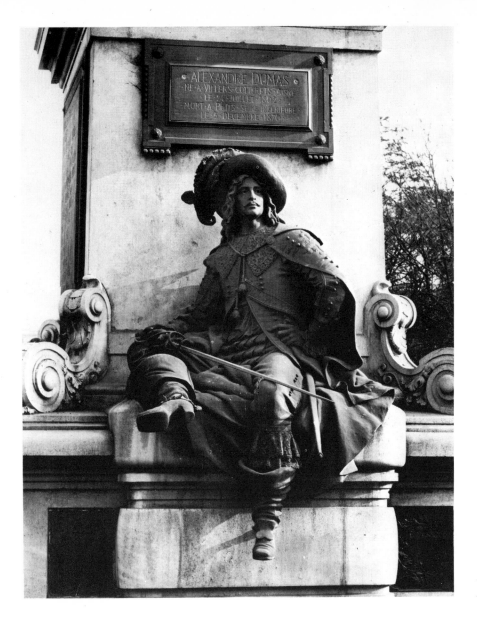

*D'Artagnan, detail of monument to Alexandre Dumas, 1883*

art by Cézanne, to launch into his first art criticism with no less than four enthusiastic articles.[81]

It did not, of course, please everybody. In the year of Doré's death a critic was comparing his version unfavourably with Johannot's. 'Doré has imagination, power of modelling and the image of light and shade. But Johannot has feeling and expression. He identifies with the writer. Doré interprets, Tony Johannot translates.'[82] In the same year another writer, Jules Claretie was asking derisively: 'What did he find in this book of Cervantes of which the hero is man? Mountains, forests, sunstrokes and moonlight!' But later generations have thought differently, and his illustrations have been echoed in countless plays and films, operas and ballets.

One of the pleasures of Doré's *Don Quixote* is that, being mostly neither bloodthirsty nor solemn, it lacks the set of props which he was apt to trot out to convey these moods. Snakes, bats, owls and gibbets crop up regularly against the wooded Black Forest hillsides which serve impartially as background for the Bible or ladies in Richmond Park. The black birds which hover for the first time over the swamps of

[81] In the *Journal Populaire de Lille* of Dec 1863
[82] Henry Houssaye, writing in *Les Amis du Livre*, 1882

52

83 The subject was Tennyson's *Vivian*, on which he was working.

84 Gordon Craig, *Henry Irving*, 1930, quoted in M. Rose

the future Leningrad in his *Russie* swoop across innumerable scenes of shipwreck and desolation until they find their ultimate embodiment as Poe's *Raven*. They even combine with his otherwise ubiquitously calamitous angels to form the rebel *anges-vautour* who tumble out of a lost paradise in a wash-drawing.

The dramatics in Doré are so striking that it is hard to realise that he was never employed for the stage. He was an addict of theatre and opera-house and loved to mount charades and shadow-plays at parties. His illustrations are often like *tableaux vivants*, with framed sets, melodramatic lighting and theatrically posed figures, and he did once suggest working on an opera with a minor composer, Charles Marie Widor.[83] But stage design was in those days the preserve of expert craftsmen and nothing came of the project; he never had his chance at the *Niebelungenlied* which he had included on his list of master-works, and the debt which he undoubtedly drew from the theatre has been repaid only subsequently, in the stage productions of nineteenth-century works which so often bear his stamp.

It was not only his settings which were dramatic; he had an exceptional gift for encapsulating a whole mood or incident. Henry Irving was later to confess to lifting a whole scene from *Don Quixote* (he used it, somewhat cavalierly, for the apothecary episode in *Romeo and Juliet*) and he was not to be the last. 'I, who owe a debt to Doré, know quite well what it was Irving found so excellent,' wrote Gordon Craig.[84] 'Decors? Oh dear, no. Drama expressed visually? Yes.'

This costume-drama dash is summed up in the lifesize statue of d'Artagnan which forms part of the monument for Alexandre Dumas he carried out in Paris. The mayor had at first wanted another sculptor, but Dumas *fils* was impressed by a sketch which Doré showed him. Out of friendship Doré carried out the work free of charge (for once he used live models), setting about modelling the swarthy tousle-headed writer seated in a chair, presiding over a group of his

*'Fire in the Place Maubert', 1848*

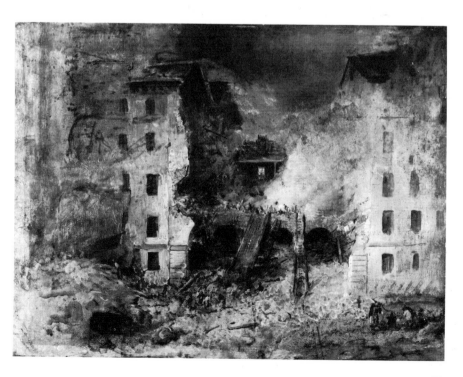

53

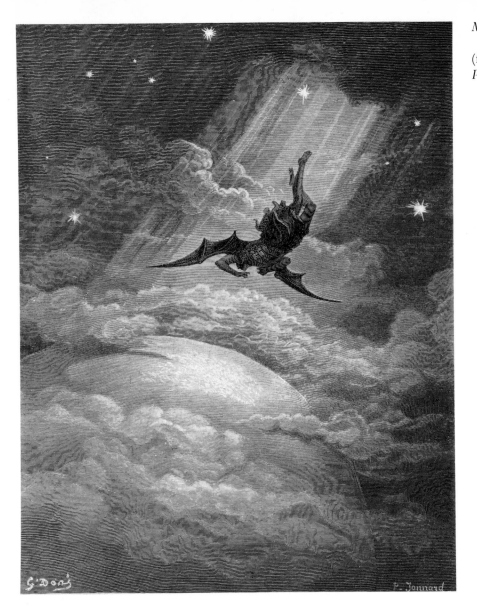

readers and over his best loved character. It was not erected until a year after Doré's death, in the Place Malesherbes, where it still looks remarkably lively and firm. The work of the self-taught sculptor compares more than favourably with the memorial to Dumas *fils* nearby—and indeed with the art deco likeness of Doré's pupil Sarah Bernhardt, which appropriately stands in the same square.

Action and energy lead all too easily to violence and this, always a latent interest, became a suspiciously congenial subject for Doré. The chopped-off limbs and heads in *Baron Münchhausen* gave way in his Rabelais to grappling crowds and toppling buildings. Even at the end of his career he returned to the subject with amazing verve in his Ariosto, where his visions of knights exploding as their horses collide, and of sea-battles with masts locked like lances, tremble on the edge of sadism.

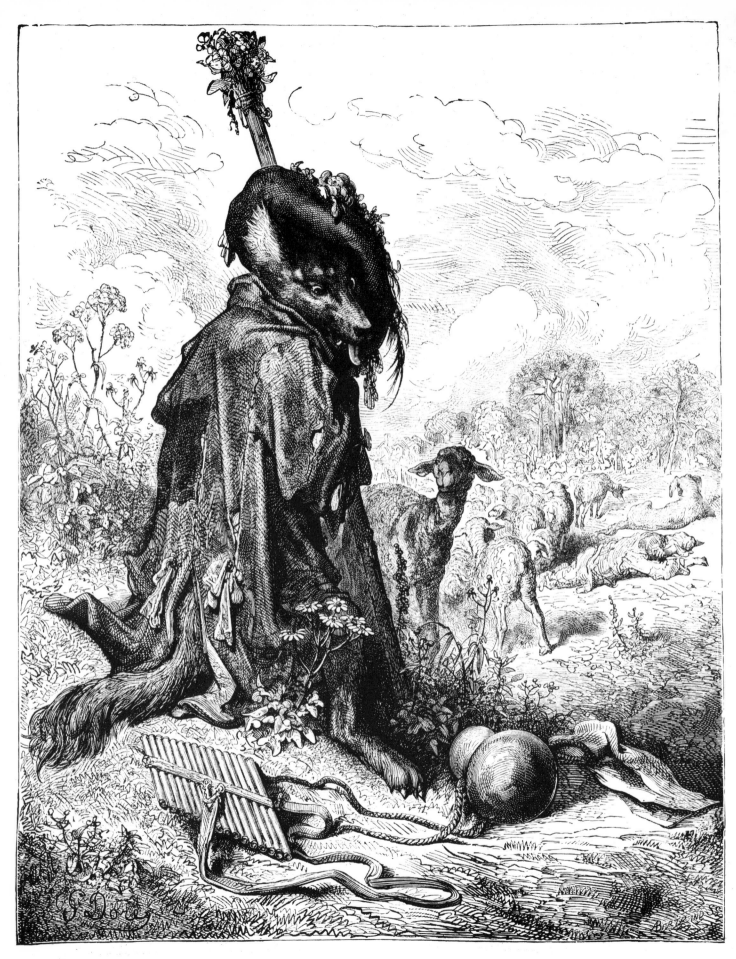

# HORROR

There is hardly a book illustrated by Doré—even *Don Quixote* is not quite an exception—right down to his hack travel-manuals and popular topical pamphlets, which does not contain some image of violent death or savage maiming. In some of them, such as Gérard's *Lion Hunting*, or straightforward war histories, the bloodshed arises naturally from primitive story-telling. Moreover the Romantic style adopted by Doré—rather belatedly, for he was always under the influence of older men—revolved round a demonic insistence on deep erotic-aggressive urges. This can be seen clearly in the subjects chosen by a painter like Delacroix, who was undoubtedly the biggest of all influences on Doré —so much so that some of his sketches, for instance for his Galerie d'Apollon decorations, come very near to Doré's, just as his *Faust* illustrations of 1828 were a direct inspiration to Doré.[85]

Doré was the least original of artists where general theories were concerned—his eager-beaver temperament jumped at any current style or standards. He shared the prevailing fashion for German art, with de Nerval translating Goethe and Gautier raiding Heine for his

*Rabelais,* Gargantua and Pantagruel, *1854*

(facing page)
*Perrault,* Contes, *1862*

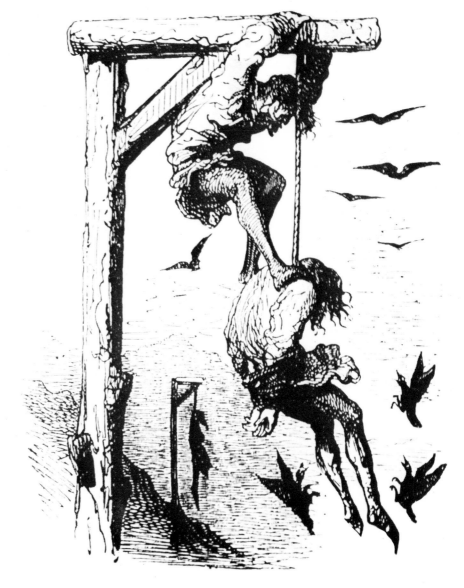

[85] Even his vision of Dante and Virgil walking through skulls trapped in ice (*The Inferno*, Canto 32, v 19) seems to have been inspired by a study by Delacroix for his 'La Barque de Dante' of 1822.

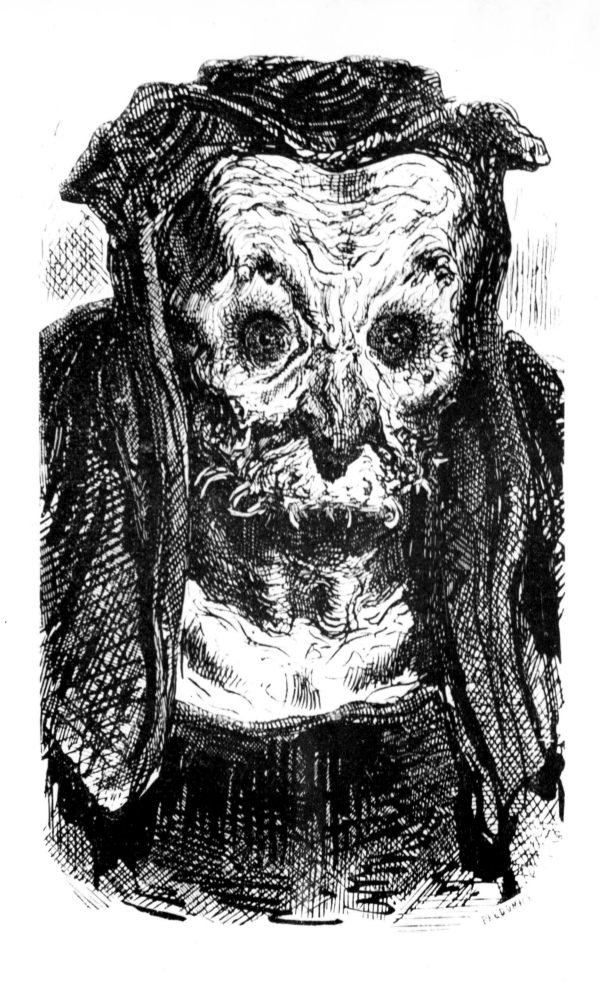

*Saintine,* La Mythologie du Rhin, *1862*

(facing page)
*Balzac,* Contes Drolatiques, *1855*

ballet *Giselle*, and the passion for all things gothic—so strong that one of his bohemian companions[86] actually used to walk around in armour. He also shared an appetite for the exotic and the wild arabesque—though in his case it usually described action rather than passion—and for those convulsions of the agonised which turn so easily into splendidly curvaceous designs and which were eventually to fade into the bloodless twinings of art nouveau. Moreover the inspired sketch was what he excelled at (thus contributing indirectly to the rise of Impressionism) and, translated into images which had to make an instant impact in the pages of a book, this demanded exaggeration.

But even with these considerations in mind, and remembering his natal half-share of gothic anguish and cruelty, not to mention a recent fashion for Goya, the frequency and relish with which he kept returning to scenes of horror contrasts strongly with his contemporaries, and still

*Rabelais,* Gargantua and Pantagruel, *1854*

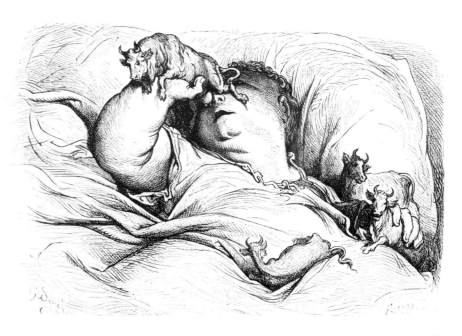

more with English counterparts like Tenniel, Leech or Doyle. It certainly struck some of his critics. Of his *Inferno* an English writer called Hamerton wrote: 'The story of Ugolino being absolutely revolting, is dwelt upon with special favour.' The blood gouting from the bellies of the boyars in his *Russie* or from the unfaithful wife in his *Balzac*, gave way to corpses dangling from gibbets (Victor Hugo shared the same curious obsession, making several studies of the subject long after the invention of the guillotine) and the skeleton of Death stalked through his pages dressed up in a dozen disguises.

These are relatively straightforward schoolboy horror-comic trappings; they led on to visions of a more disturbing kind—hideously disintegrating faces and repellent flights of fancy such as a dead giant's

*Saintine,* La Mythologie du Rhin, *1862*

*Rabelais,* Gargantua and Pantagruel, *1854*

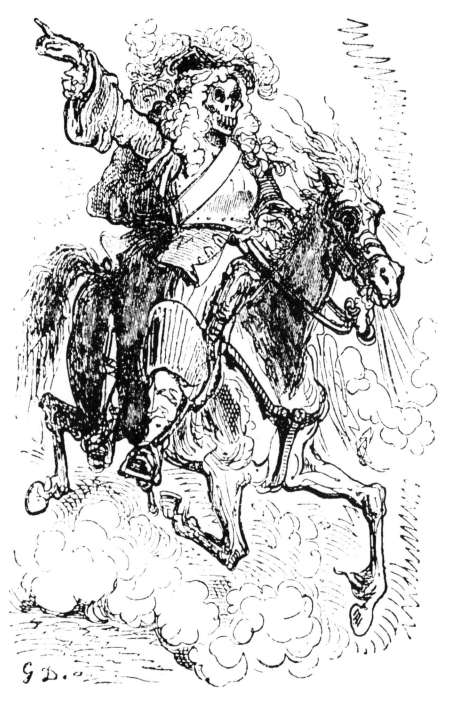

*Saintine,* Le Chemin des Ecoliers, *1861*

(facing page)
*Cervantes,* Don Quixote, *1863*

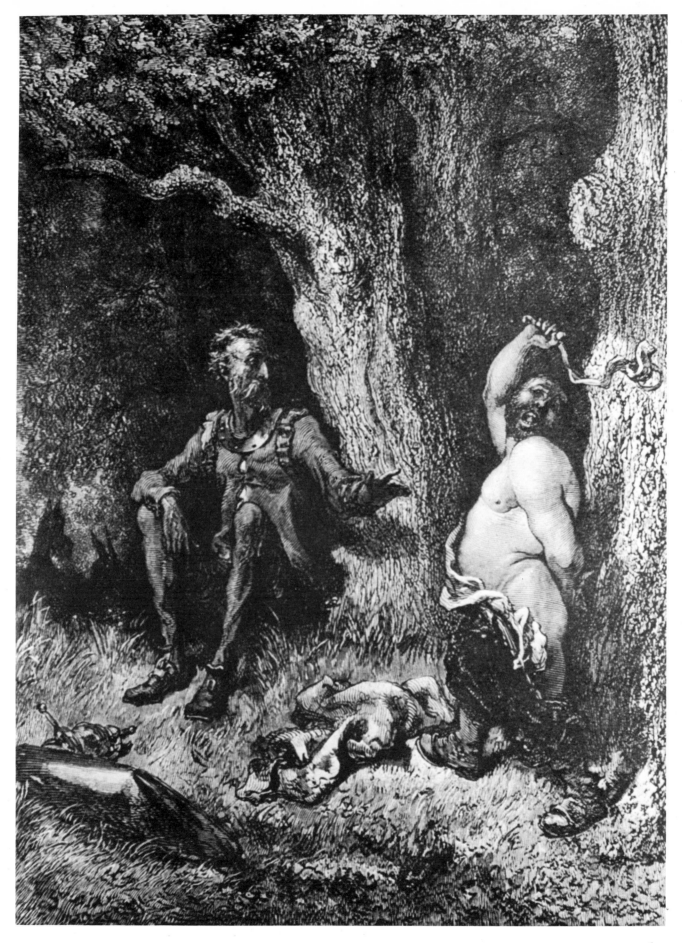

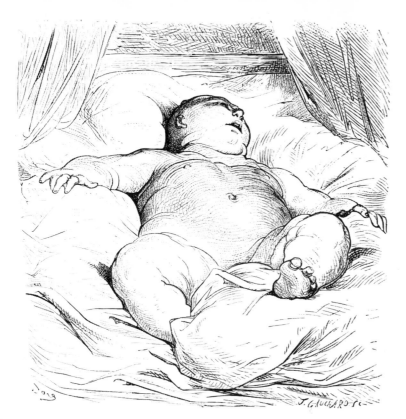

*Rabelais,* Gargantua and Panta-
gruel, *1854*

*Montaigne,* Essays, *1859*

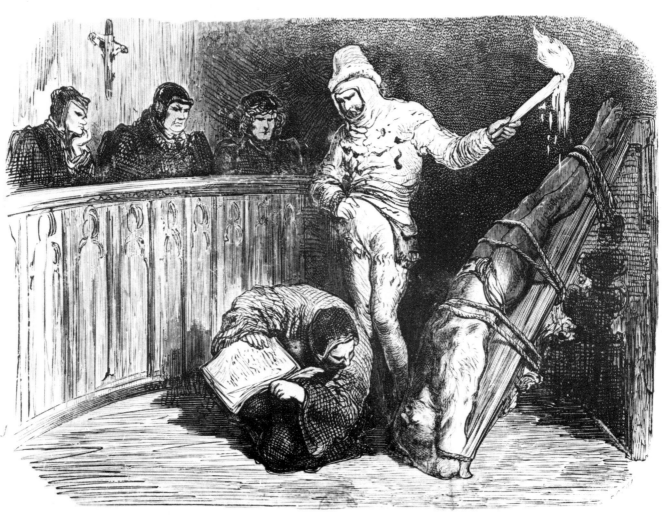

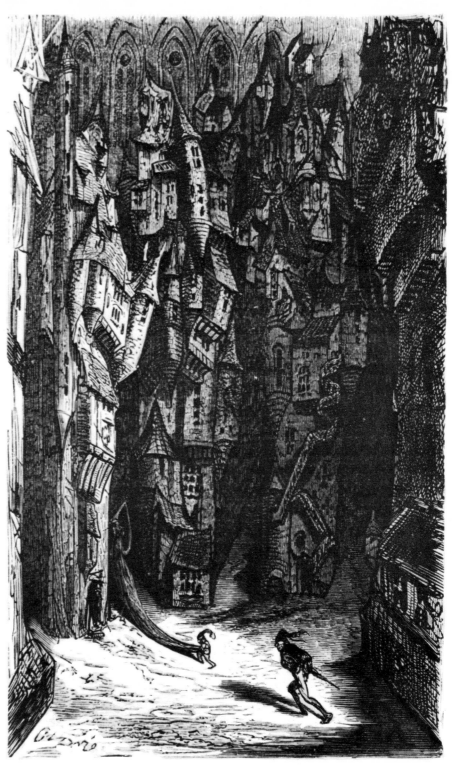

*Balzac,* Contes Drolatiques, *1855*

open mouth serving as a lair for foxes, or the huge knife of a Perrault ogre poised over the throats of sleeping infants. Even the urbane *Essays* of Montaigne incongruously furnished the excuse for a torture scene and Doré did not shrink from making a full-page—and typically convincing—study of a man being ceremonially garotted.

These suggest some disturbance in Doré's personality—an anxiety and aggressiveness which contrast curiously with his lively and sociable exterior. Perhaps even more revealing is an obsession with chimeras (a link with Moreau and the Symbolists) and above all with giants. Doré

63

*Saintine,* La Mythologie du Rhin, *1862*

had a gift amounting to genius for suggesting huge spaces and outsize figures—the world as it appears to a small child. His viewpoint is often that of a Tom Thumb. In his Rabelais he managed to draw a simple baby so that it looms like a hippopotamus, in his Balzac the buildings (an Expressionist version of Strasbourg) tower up to imprison the midget

*La Fontaine,* Fables, *1867*

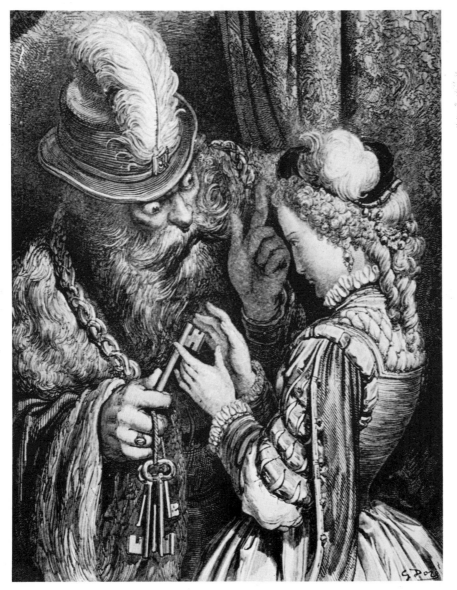

*Perrault,* Contes, *1862*

*Rabelais,* Gargantua and Panta-
gruel, *1854*

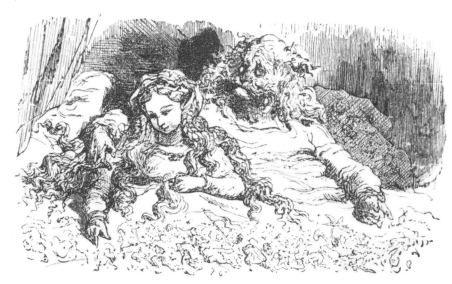

*Balzac,* Contes Drolatiques, *1855*

inhabitant. From Gargantua to the ogre in his Ariosto enormous bodies
bulge out from the page.

These reflect anxiety, not aggression, and the same terror—in which
the reader, and also presumably the artist, identifies with the victim— is
conveyed in the scene in his *La Fontaine* where a vast hand stretches
down to feel for cowering mice, an enormous hare looms up against the
moon to terrify the frogs, and wolves's eyes suddenly burn over the
door of the sheepfold.

Fear emerges in more significant visions of serpents (he made a
lithograph of one attacking a nestful of young birds), powerfully
coiling sea-monsters and, in one case, a snake-woman gripping a man's
leg in her tail. We sense something awry in the oddly drawn scene of
Sancho Panza whipping himself with a snaking belt, and dread

*Rabelais,* Gargantua and Panta-
gruel, *1854*

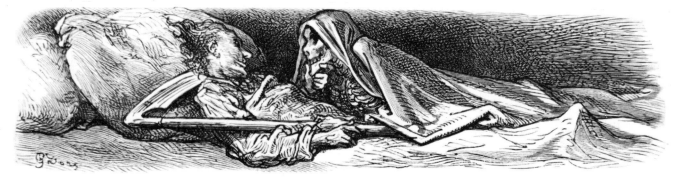

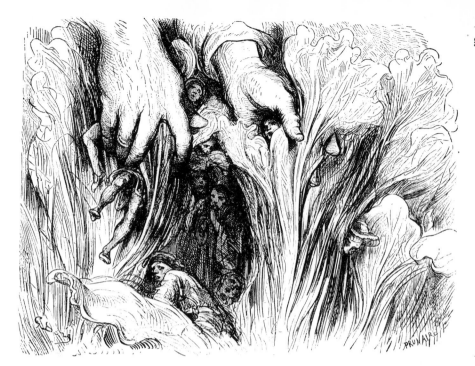

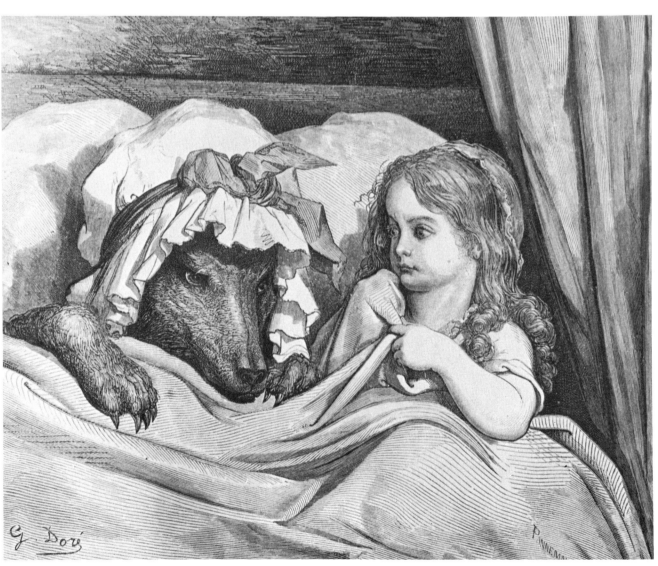

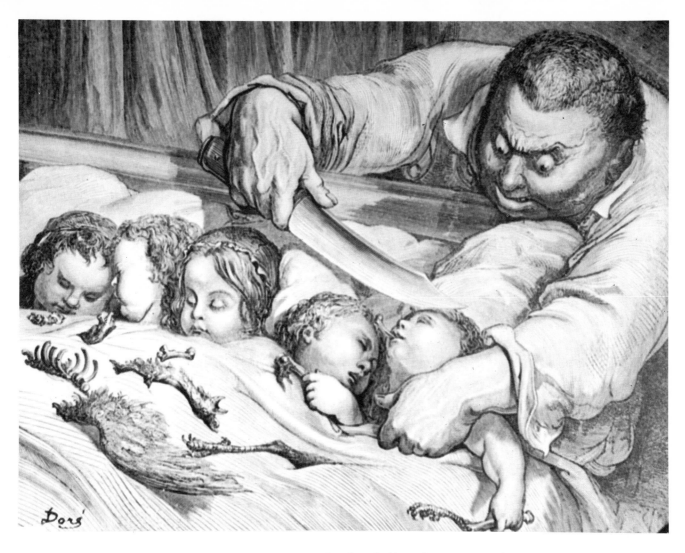

*Perrault,* Contes, *1862*

appears most plainly of all in the picture of Red Riding Hood in bed with the hairy Wolf—in a woman's cap.

A thousand nightmares for a child lie buried in these images, and they provide rich material for the psychologist. Doré's sex life remains curiously imprecise, and the clues in his art are ambiguous. Unlike most Salon artists of his time, he never embarked on erotically sprawling goddesses and nymphs, and the confident rendering of his muscular men (often borrowed straight from Michelangelo), compared with his insipid and vaguely drawn heroines, was also noticed by his critics.[87] But to infer latent homosexuality is probably too glib an answer. For some reason—perhaps psychological—he almost never worked from models, and he may simply, as he averred, have become more familiar with male anatomy at the swimming bath. Though his closest friend, Kratz, remained unmarried, most of his intimates were enthusiastically heterosexual, and he seems to have had genuine attachments to women. Roosevelt[88] talks of an early passion for a young girl, quickly nipped in the bud, and of an engagement shortly before his mother's death—a relationship which was mysteriously broken off. Goncourt writes of 'amorous letters' found after the death of the actress Blanche Ozy; he was close to the beautiful young Sarah Bernhardt and did a series of charming and sensitive drawings of a distinguished looking young woman. He certainly indulged in some erotic activity; in a letter to

[87] 'His idea of the female face and figure is frequently unpleasing; the face insipid, the figure lank and ungraceful.' E. Ollier
[88] She describes him, though, as 'somewhat effeminate'.

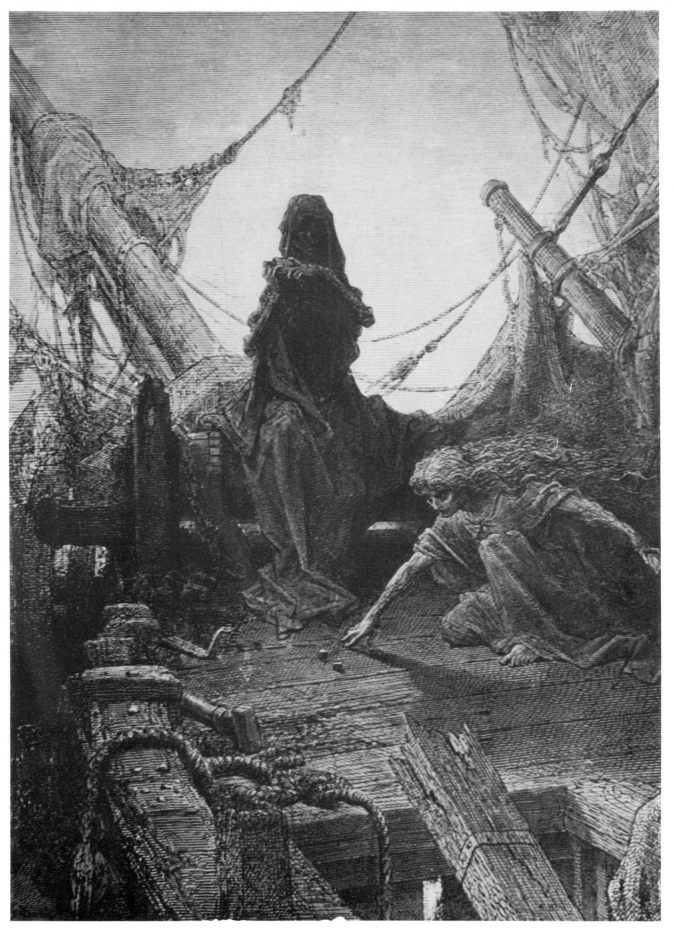

*Ariosto,* Roland Furieux, *1879*

(facing page)
*Coleridge,* The Ancient Mariner,
*1875*

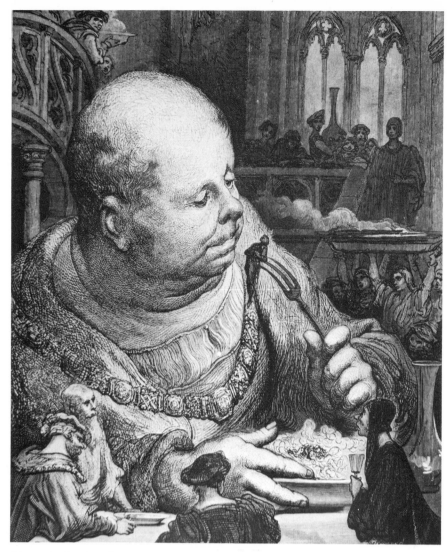

*Rabelais,* Gargantua and Panta-
gruel, *1854*

*Rabelais,* Gargantua and Panta-
gruel, *1854*

Kratz he invites him to an evening to which some 'young persons' have
been invited. But on the whole it is safe to conclude that he had a basic
fear of sexual entanglements of all kinds.

Whatever the cause, Doré was a master of horrific art; not the private
and personal kind which appears today in a painter like Bacon, but—as
usual with Doré—general and vague. At its best it developed into an
even wider, almost cosmic terror—the awful visions of Dante or *The
Ancient Mariner.*

The first romantic ballet, *La Sylphide*, was created in Paris the year of Doré's birth.

(facing page)
*Dupont,* The Wandering Jew, *1856*

*'Scottish Loch'. Oil, about 1873*

The borderline between fear and worship is a thin one, and declining anxiety about the wrath of God in the eighteenth century led to an ever-increasing wonder at the mighty powers of nature. Doré was a belated child of this Romantic reaction, poised between the 'sublime' visions of Turner and Fuseli, the dynamic surges of Byron, Berlioz and Delacroix (with their revolutionary undertones) and the safer establishment *frisson* of naiads, sylphs and picturesque picnic-spots.[89]

He tended naturally towards the splendidly tumultuous, the nineteenth-century leaning towards giantism which engendered the big orchestra, the grand opera-house, the vast canvas and the folio volume, phenomena which rapidly became absurd symbols of a swelling economy. The three books on which Doré lavished most care are all cast in this heroic mould, and artistically they are perhaps his most successful.

The first inkling of this tendency appeared when he was only twenty-four in a short book with enormous plates, *The Wandering Jew*. It was a nordic legend which had already been treated by Dürer and Cranach, here based on an account of 1774 (in *Bruxelles en Brabant*) which tells how the citizens of that city saw the Jew pass by 'at six pm on April 22nd, all bearded'. Doré found a new publisher, Michel Levy; there was a prologue and an epilogue, not to mention a musical setting of the ballad by his brother Ernest. The plates, 18in by 12in stretched the

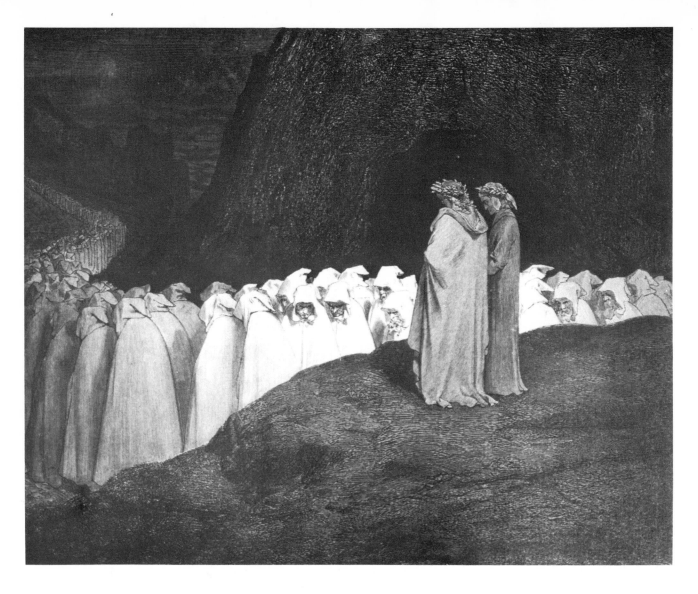

engravers to the uttermost, and introduced a new tonal treatment of the block which suggested painting rather than drawing.

Today most of the plates look decidedly overloaded, but they made a big impression at the time. 'His landscape is luminous with picturesque beauty and radiant with local truth,' wrote his English translator, George Thornbury. 'It takes one's breath away to consider what a cannon-ball rush this Doré drives on through all the world, following his Jew.' Though the publicity compared him to Blake, the book was not a commercial success.

The new big format and tonal emphasis offered possibilities of greater depth and volume and emotional resonance, and he developed it even further in his next major book, Dante's *Inferno*. This was entirely his own idea. He had begun thinking about it, he tells us, when he was only twenty-three, using a French text (by Pier Angel Fiorentino). He worked on it for three years, taking unusual care both over the drawing (helped perhaps by a visit to North Italy with Dalloz, when he overcame his former dislike of Italian painters) and over the engraving. He paid out of his own pocket for the wood-blocks (at three guineas each), the engravers and the excellent paper and printing. Even then he had difficulty in finding a publisher. At last Messrs Hachette

*Dante,* The Inferno, *1861*

(facing page)
*Dante,* The Inferno. *Pen and wash, 1861*

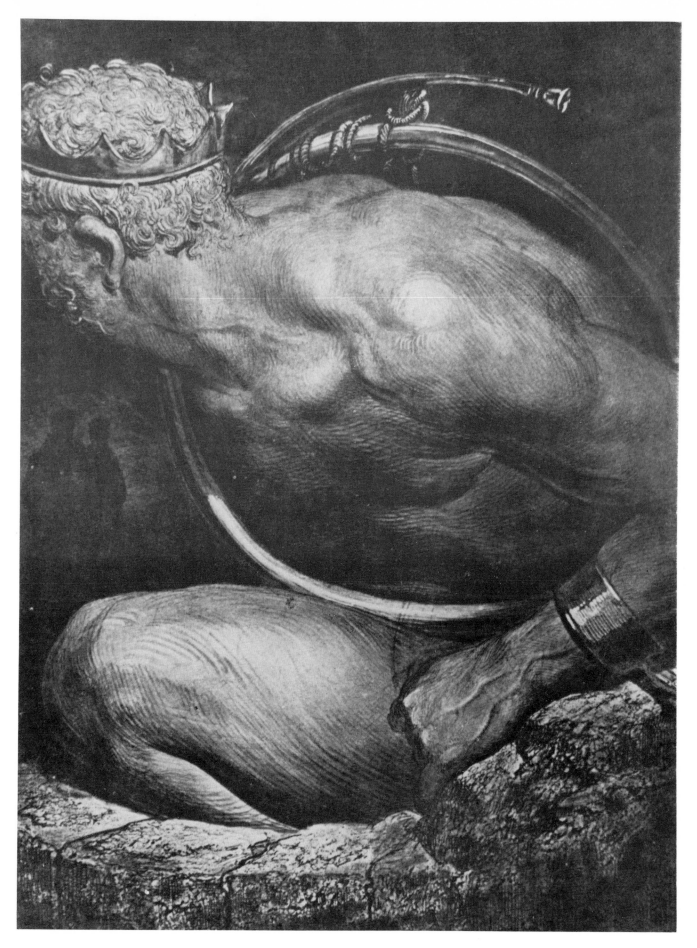

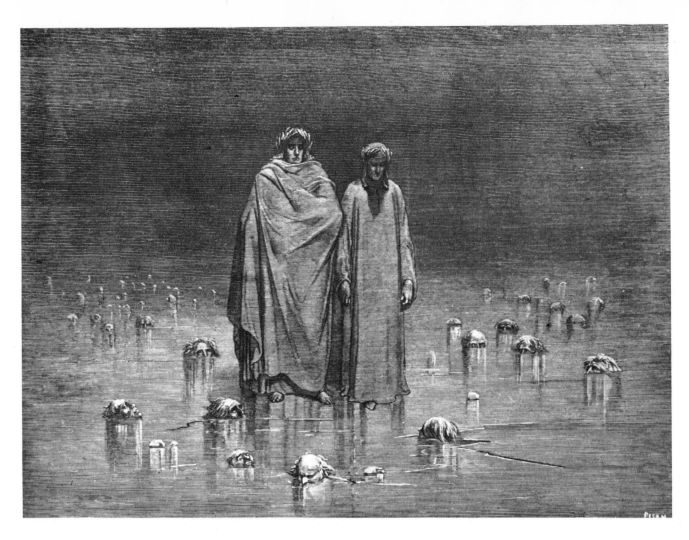

reluctantly agreed. 'You won't sell 400 copies,' they warned him. In fact the edition of 3000 sold out (at 100 francs) within a few weeks, and was subsequently translated into many languages. Moreover it got rave reviews. 'To find anything comparable to the effect produced by this really sublime composition,' wrote Gautier of the 'Dante and Farinata' plate, 'we must go back to Rembrandt's "Raising of Lazarus".'[90]

It was a tremendous imaginative feat, whose only rivals (Michelangelo's *Inferno* drawings having been lost) are Botticelli and Blake, and it was to prove an inspiration for later artists. His flying monster for Canto VII (perhaps a portrait?) could have been dreamed up by a Symbolist thirty years later, or indeed by Surrealists like Max Ernst or Tchelitchev or Dali. With astonishing versatility—for nothing in his Rabelais or Balzac had suggested it—he had switched to a totally new landscape of the mind, a rocky, precipitous terrain as barren as the moon, at the same time claustrophobic and vertiginous.

A new severity crept into the drawing; the spatial layout became both daring and sharply defined and even the contorted figures work expressively together. Doré's lack of scholarship here becomes a positive advantage, balancing him between the slightly dry narrative of Botticelli and the extravagant poetry of Blake (his illustrations suggest that he was familiar with both artists). Through dizzy vistas which may have been derived from John Martin, who was popular in France at this time, the gaunt figures of Dante and Virgil pass like

*Dante,* The Inferno, *1861*

(facing page)
*Coleridge,* The Ancient Mariner, *1865*

90  *Le Moniteur Universel,* 7 July and 1 Aug 1861

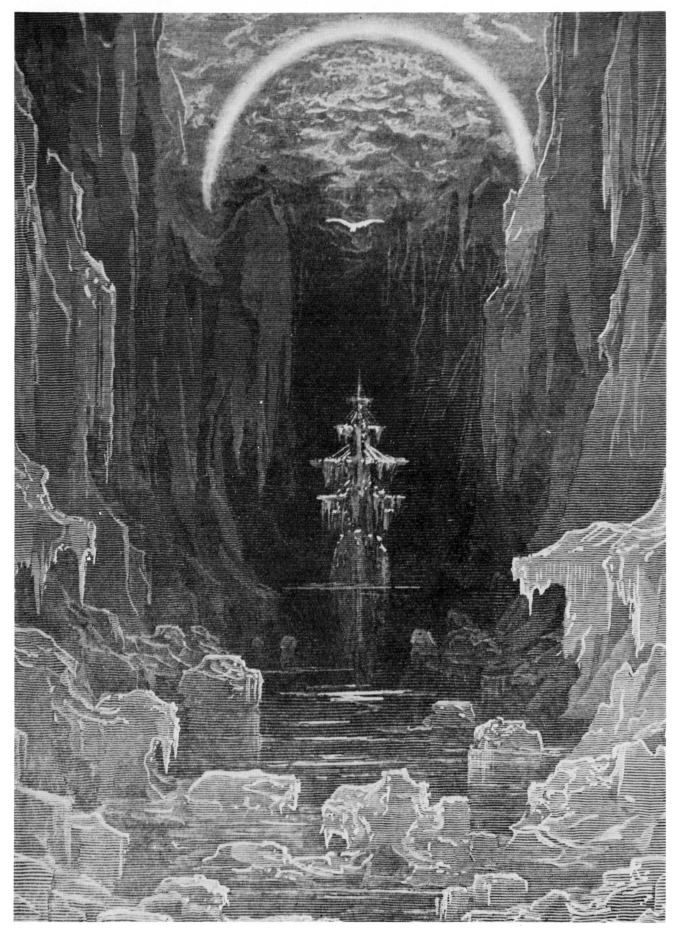

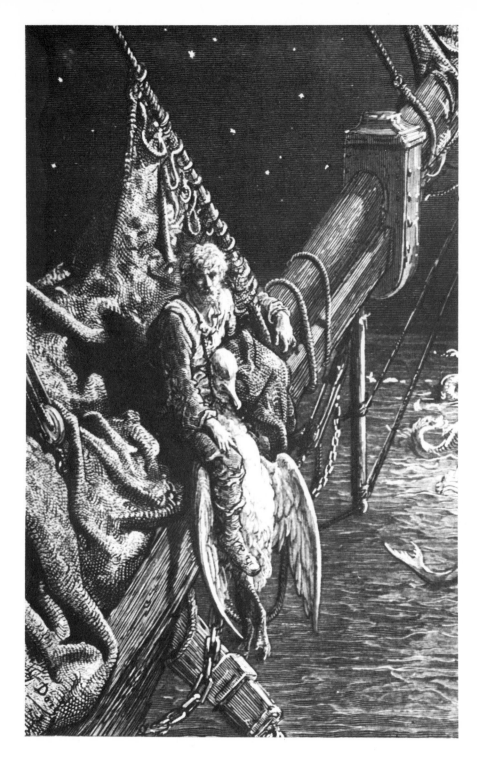

*Coleridge,* The Ancient Mariner, (*detail*), *1865*

ghosts of stone, dramatically spotlit heroes of some unwritten Verdi opera, poised above the winding anonymous crowds which were to be echoed in the films of Eisenstein.

The effects were obtained through superbly skilled engraving, printed on fine paper (with cunningly tinted surrounds to set off the whites). Working from black to white, the dark passages are as rich as mezzotints and started a vogue for tonal engraving which was to last right up to the reforms of the Kelmscott Press. The special master of this technique was Pisan (he was later chosen to cut the whole of *Don Quixote*) who translated Doré's violent chiaroscuro, at this time still

(facing page)
*Dante,* The Inferno, *1861*

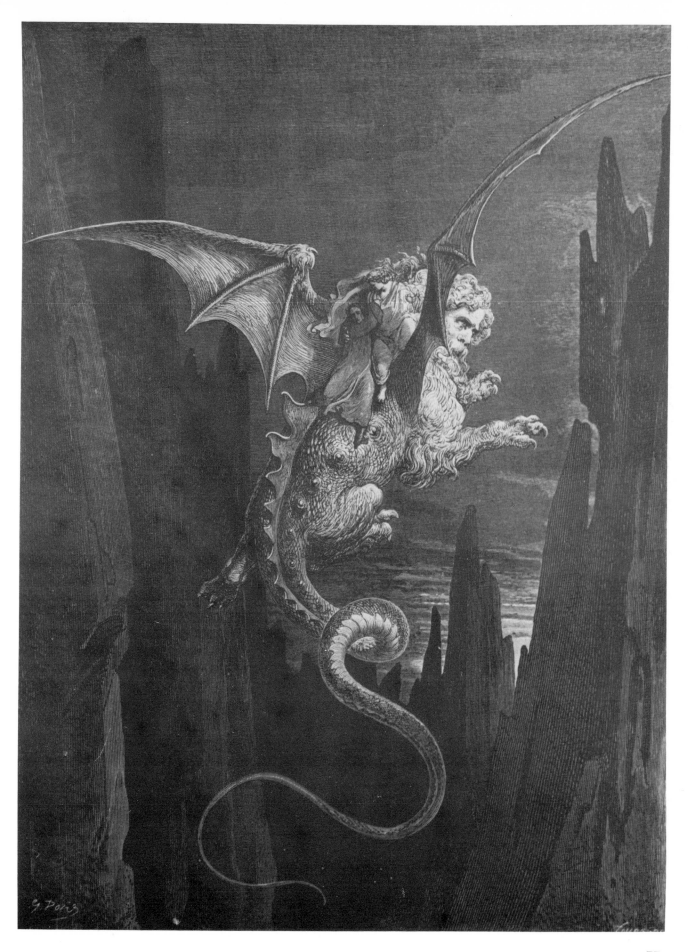

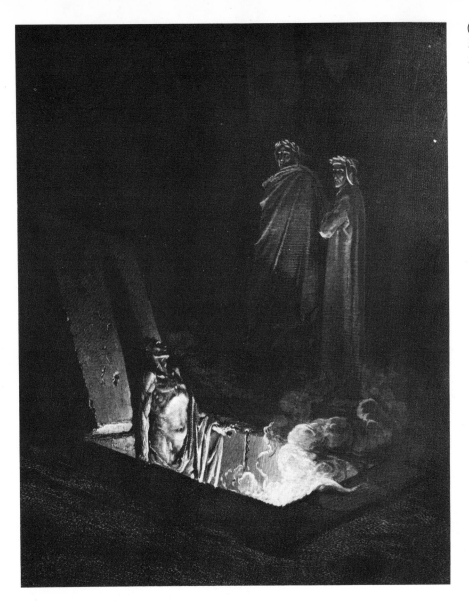

*Dante,* The Inferno, *1861*
*Dante and Farinata*

washed straight onto the block (later he took to making drawings on paper) with wonderful ingenuity. For good or for ill, Doré's demands and the skill of his engravers in fulfilling them[91] influenced the history of engraving strongly.[92] Even the English steel-engravers who were to undertake his Tennyson plates succeeded in bringing out a tapestry-like pre-Raphaelite melancholy which was entirely appropriate.

This approach was near to painting and Doré's dream of becoming an easel-artist is very visible. 'He talks rarely of his drawings, much more of his painting,' recorded Claretie. He tried repeating his famous illustrations in picture after picture, but with no success. He did suggest natural grandeur in a few mountainscapes; but he was really happier in smaller Barbizon-school type scenes, and happiest of all in water-colours; it is possible that if he had been born in England he might have become a great watercolourist.

As it was, he despised this modest medium and his search for greatness led him, disastrously, to 'noble', ie morally edifying, themes. He had not been taught the technique of oils and (unlike, say, Francis Bacon today) he never acquired it. He seems to have had little sense of colour,

[91] H. Leblanc lists 137 in all
[92] See Jules Lethève, *Bibliothèque Nationale, Cabinet des Estampes, Vol 7, 1954*

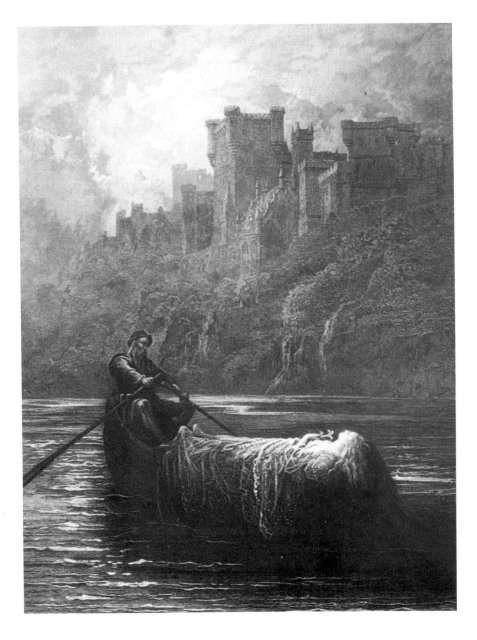

*Lord Tennyson,* Elaine, *1867*

though he declared fervently that 'colour is to drawing what the soul is to the body'. Apart from a few isolated examples, such as the satirical 'Englishman', probably painted about 1871 and clearly influenced by Manet, and some landscapes in the Barbizon-school manner, his entire output as an oil-painter must be written off. His fellow Frenchmen never accepted this side of his work; he knew this and the knowledge helped to kill him.

The English public, on the other hand lapped him up, encouraging all that was mawkish and anecdotal in his art. He mistook sanctimonious Victorian religiosity for high moral purpose (he would never have got on with Ruskin) and England proved a malign influence. But it was an English poet who struck from him—right in the middle of his most cliché-ridden period as a painter—his last brilliant imaginative spark. Milton's *Paradise Lost*, had proved an unexpected failure, only Satan coming alive as a kind of proto-Batman; but Coleridge's weird ballad of the *Ancient Mariner* (did it recall the legend of that earlier, Jewish, outcast?) struck a chord in the breast of this prosperous, middle-aged

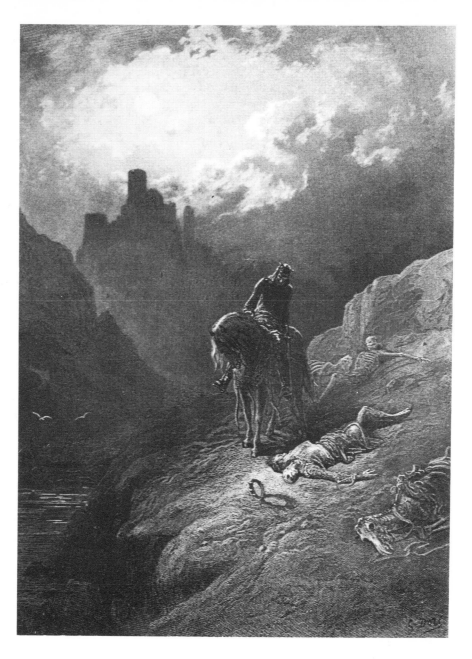

*Lord Tennyson,* Elaine, *1867*

Parisian. He planned another of his lavish editions, carrying out thirty-eight enormous drawings which he had carefully engraved. The unearthly story inspired some of his most unforgettable images. English mist turned under his brush into frozen fog, the accursed ship sits gripped in a glittering coronet of ice, tossed on heaving seas or lying stranded on wastes of water lit by some invisible gleam; the spectre of death crouches on deck like a bundle of blackened sail.

He published the book himself from his Bond Street gallery.[93] It was a big risk—the engraving alone had cost him £3,500—and it proved a resounding failure. After his death 450 copies were found in his studio still unbound.

His imagination would never soar higher but it had been struck down, like the fateful albatross in the legend, by the very weapon he had forged himself—a lack of mass popular appeal. We sense here a note of real tragedy in a career which can too glibly be interpreted as a slow upholstered slide into mediocrity.

[93] There seems to be no record of the size of the edition

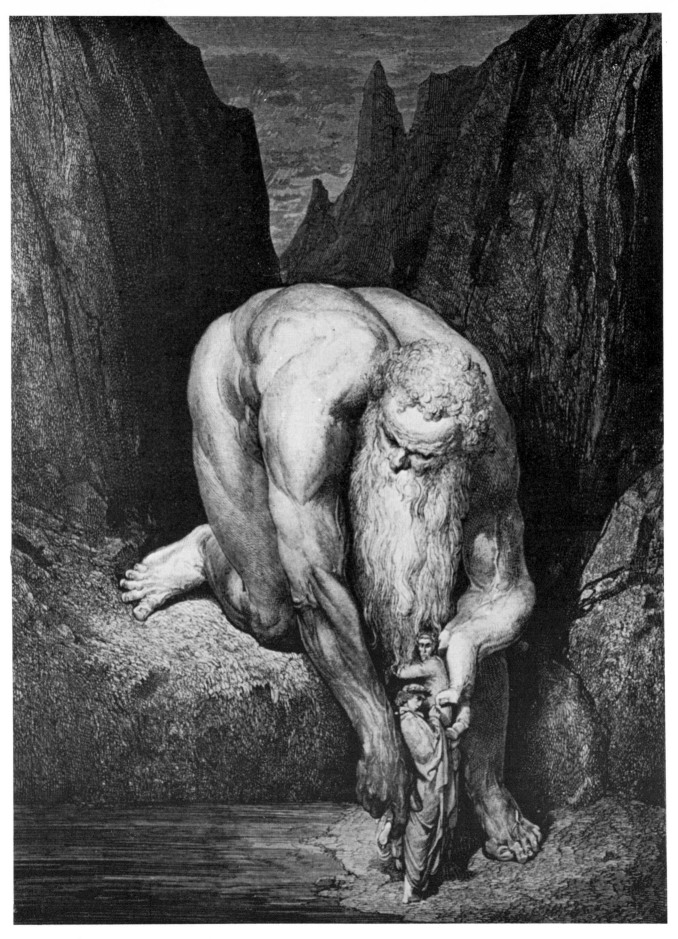

94 Preface to *Baron Münchhausen,*
1862

The quality which approving critics like Gautier admired in Doré was his imaginative dash. 'Nobody better than this artist can give a mysterious and deep vitality to chimeras, dreams, nightmares, intangible shapes bathed in light and shade, weirdly caricatured silhouettes and all the monsters of fantasy.'94 It still astonishes. Not only could he conjure up in an instant a scene complete with props and characters; he also had a knack of inventing expressive poses and movements (in the *Don Quixote* vignettes, for example) and that rare extension of vision which, once a viewpoint has been decided on, can reconstruct every item within it accordingly. His disregard for studio models gave him total freedom in this respect. Whether it is a human, or monster's head seen from below or a horse seen from above or behind (as in his charming sketch of two boy grooms), his imaginative grasp of form enabled him to attack the subject with firmness and confidence. His contemporaries were amazed at the way he could return from a long and varied excursion and recreate a succession of different scenes from memory.

He did, in fact, make a practice from his earliest days of carrying a note-book for isolated details or lightning summaries of a composition. In some surviving pages we can see the swirling arabesques in which he trapped a crowd in action, or the sharply observed and recorded particulars of the rigging and mechanisms of the ships in the Port of

(facing page)
*Dante,* The Inferno, *1861*

*Antaeus*

Les Différénts Publics de Paris, *1854*

84

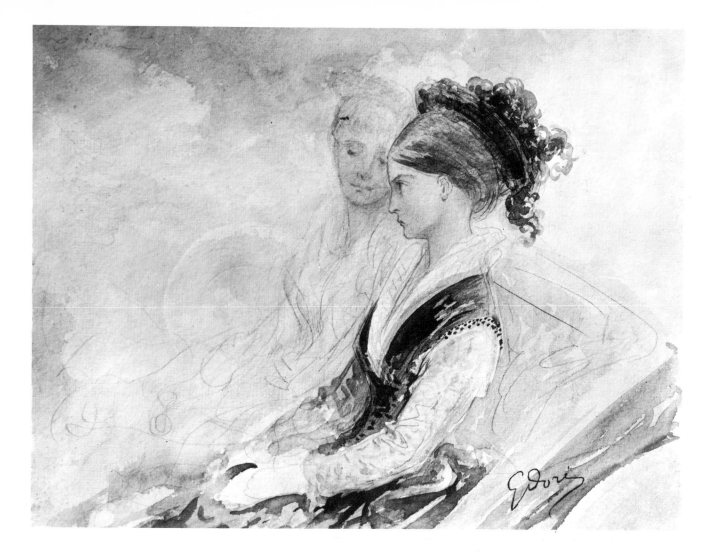

'*Two Ladies in a Carriage*'. *Water-colour, probably about 1870*

(facing page)
'*Les Emigrants*'. *Pencil, undated*

[95] Though captioned—apparently with an engraving tool—as an episode of this year, the assured handling of the picture (now in Mr Brinsley Ford's collection) suggests either a later date or unbelievable youthful virtuosity.
[96] Mentioned in a letter to Rappard of Sept 1882 and also in a letter to Theo of Dec 1889
[97] René Delorme, *Gustave Doré*, 1879

London. There is even a page of anatomical studies, though they look as if they had been taken from a book.

His early lithographic albums of Paris types, a striking painting of a building still smoking after the riots of 1848,[95] and the huge water-colour portraits of his mother and the maid Françoise (done in 1879 and 1881 respectively), touchingly detailed down to the blue-veined old hands, show that he was well able to draw convincingly from life. There are probably other uncatalogued drawings with the same objectivity, such as the group of sea-bathers which impressed Van Gogh,[96] though the number of his original drawings is uncertain. Owing to the habit in his youth of drawing directly onto the wood block (which was then of course, destroyed by engraving) most of them date from his last decades, sometimes consisting of repeats of, or variations on, successful illustrations. Even these may not be very numerous. The catalogue of a sale at the Hotel Drouot on 22 May 1875 states that there were only fifty apart from the seventy on sale, while Delorme[97] puts the number even lower—'probably no more than forty in the whole world'. But Leblanc suggests 526, of which he actually lists a good number.

But Doré's imagination was so dynamic that, when he abandoned the higher flights of fancy to deal with more mundane subjects, it is hard to tell where truth ends and make-believe begins. His imaginary portrait of Rabelais looks as though drawn from life just as directly

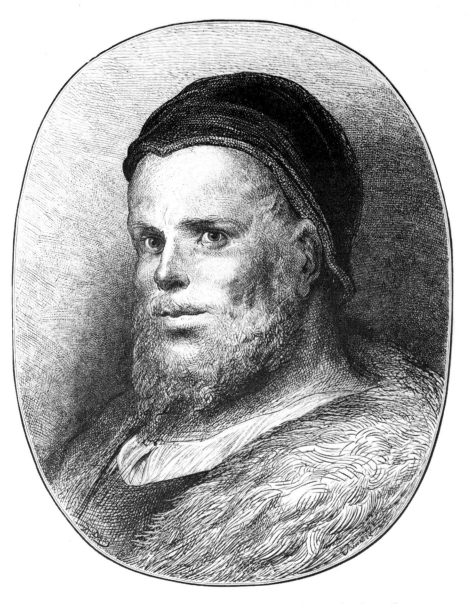

*Portrait of Rabelais,* Gargantua and Pantagruel, *1854*

as the real portrait of Rossini was drawn from death. Like many artists of his time he collected a large stock of costumes and armour and objects, which recur in many of his illustrations and which he must have known by heart; and he joined in the general practice of making free use of other people's engravings (it was said that 'Delacroix took Rubens as other people took coffee'), a practice which enabled him to illustrate without the least hesitation or embarrassment the costumes and physiognomy of the Bashi-Bazouk or a Hottentot at home or a detail of a Moorish doorway. We read that for his illustrations for Taine's travels, he supported his own notes and memories by photographs.[98] But the extreme sketchiness of his London notes compared with the detail in the finished plates reveals how much he could rely on what he called—in a phrase which shows that he was well aware of the camera's potentialities—the 'collodion in his head', of which he said he had plenty.

Some vivid examples of this photographic memory appear in the animals and birds of his *La Fontaine.* There are horses and dogs, birds and sheep and insects, all so lively that they give the illusion of having been studied from life. The little vignettes, bursting out of their nutshell

[98]  B. Jerrold

*La Fontaine*, Fables, *1867*

format, are specially convincing. French critics in general have found these illustrations lacking in the famous La Fontaine charm. 'Monsieur Doré claims that he makes a grand effect; but when you illustrate La Fontaine the point is to make a true one,' commented Claretie. It is true that he confessed to finding the job a 'crushing' one; he seems to have been seeing at this time the poet Lamartine, who disapproved of the fable-teller, finding his industrious ant a stupid parvenu, 'the grasshopper is worth two of him'.[99] To Doré's contemporaries these un-idealised impressions evidently smacked of the dreaded Realism.[100] He was associated by some critics with Courbet, who is even reported to have once remarked: 'There is only him and me.'[101]

Such mental records were not, of course, always reliable and Doré was the object of some rather absurd accusations of inaccuracy. His

*'Lady Archers'. Pencil, probably about 1870*

[99] R. Delorme
[100] Doré seems to have been in touch with the Realist circle in the 1850s, for instance illustrating *La Revue Bucolique de Jean Raisin*. 'It would have been proper to add Courbet and Doré to the Chevaliers', wrote Théophile Gautier of the Legion d'Honneur awards after the 1861 Salon. Gerstle Mack, *Gustave Courbet*, 1951
[101] J. Valmy-Baysse

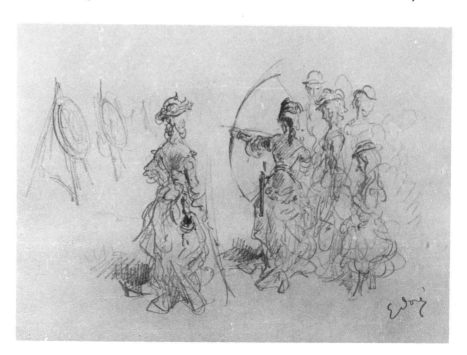

detractors complained that in his *Mythologie du Rhin* he showed a fifteenth-century church spire over a caption mentioning the year AD 510. They overlooked the preposterous Cecil B. de Mille architecture of his biblical scenes to complain of the unseaworthiness of the infant Moses's cradle; and even his idolator Blanche Roosevelt remarks tartly of his London flower-sellers that they are not Anglo-Saxon.

The accusations are true but irrelevant. Doré's truths were of a different order. He was, as a perceptive German critic has remarked, not an accuser-cum-judge like Daumier, but a witness[102]—and even then he was a witness who saw with what Ruskin called 'the soul of the eye'. Like a child he seems to make little distinction between fact and fiction.

*'Baby'. Pencil, 1870*

(facing page)
*Opium Den*, London, *1872*

102 Konrad Farner

The capacious and infinitely varied world of Doré's dreams constantly smack of youthful fancies—his stalwart heroes and doe-like heroines, his ogres and monsters, his impossible feats and improbable disasters spring from a personality in which the first fresh poetic visions of right and wrong have never been clouded by the prosaic facts of life.

This leads to much over-generalised and absurdly inflated fantasy but also to the darting flights of his imagination. It makes all the more striking the occasions when his eye 'saw true'; never truer than when, in his last years, the scales fell away in a city unhaloed by youthful memories and ambitions—London.

Of all his books, his *London* is the best-known, most discussed and the one most likely to survive. Fantasy can be bettered but facts can never be repeated, and Doré's record of the nineteenth-century metropolis stands as a monument to an actual place and time and society. It is a complete exception to the rest of his work (though faint

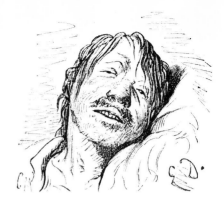

*Head of Dead Man*, Le Roi des Montagnes, *1861*

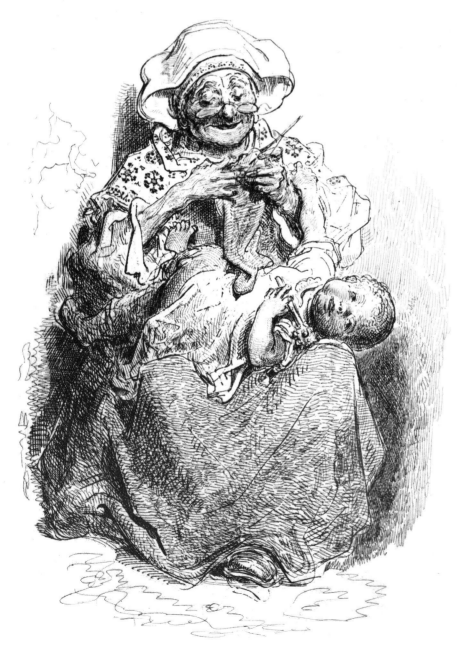

*'La Grand'mère'. Engraving, undated*

90

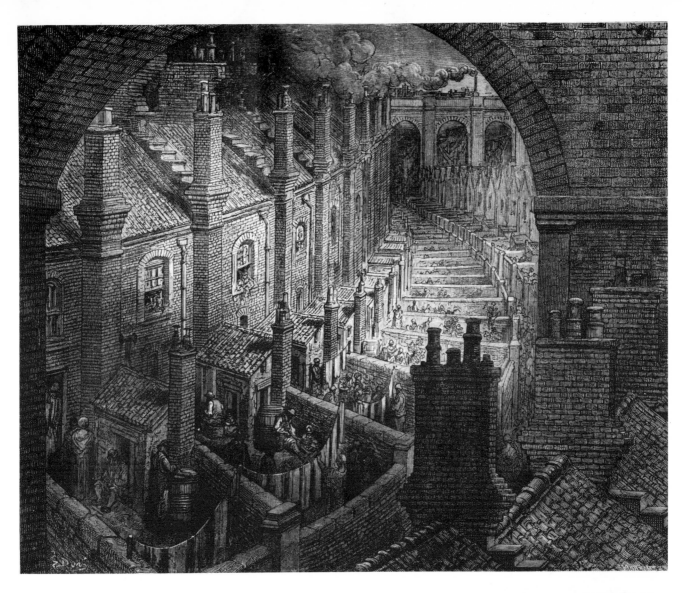

(both illustrations)
London, *1872*

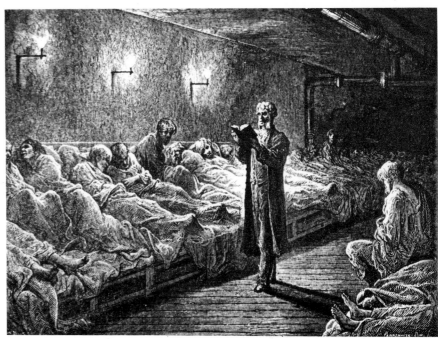

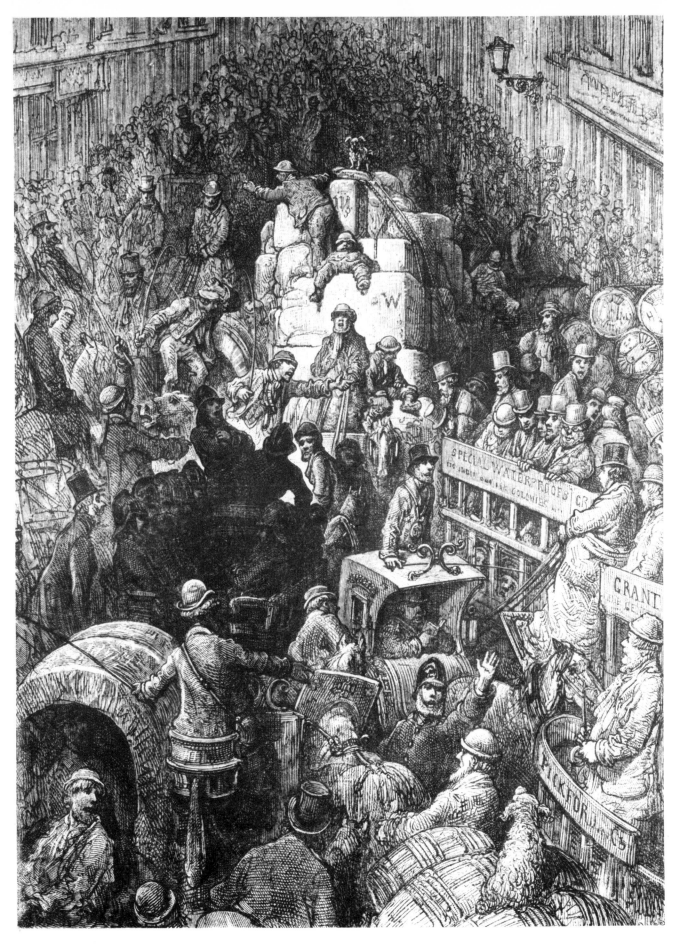

(both illustrations)
London, *1872*

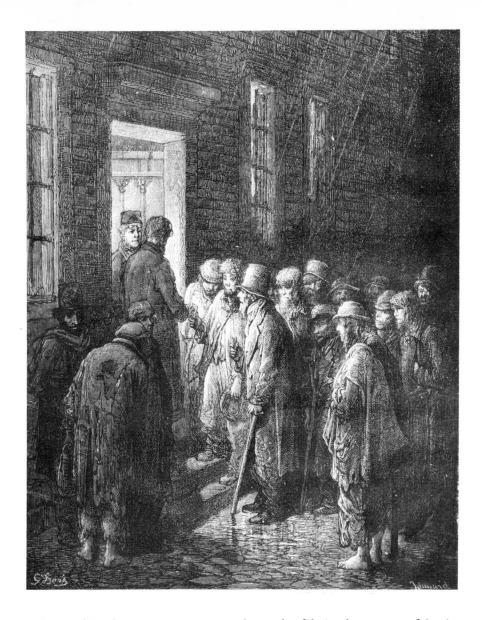

echoes of its documentary approach can be felt in the scenes of Spain which he made when he visited it with Charles Duvillier six years later) and there is no easy explanation for it. Not all the plates are successful; most of the fashionable scenes lack elegance and truth. But the haunts of the poor unexpectedly drew out the best in his art. There are no flaming sunsets here, nor conveniently hovering crows; no spires or haunted forests. Instead a sullen light hangs over the crowded roofs. Soot seems to grime the plates; we detect the ring of iron, the thud of wood and leather, the drip of water through dry-rot and grime. If you want to see the hard under-belly of capitalism and industrial exploitation, here is the evidence. The dead-beat and dishonest characters, the leaden pressures of poverty, the smell, even the slow pulse of this monstrous leviathan are caught in a set of images which puts 'the last of the Romantics'[103] among the first and finest exponents of realism.

[103] David Bland, *History of Book Illustration,* 1958

93

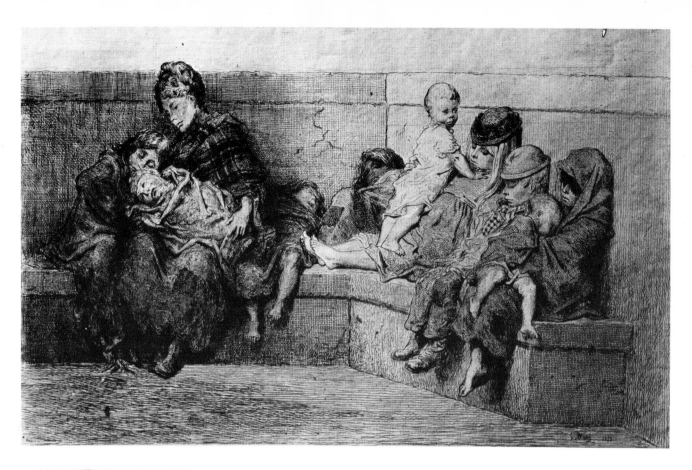

*'London Beggars'. Etching, 1873*

*'La Mendiante Assise'. Pencil, un-
dated*

# COMPASSION

The boisterous heartlessness of youth faded slowly but surely out of Doré's art as he grew older (the violence in his very late *Roland Furieux* is strictly mythical). In his early works it had been true that, as a critic was to write, 'If he has tears at all, they are the iron tears of Pluto rather than the gentle waters of human grief.'[104] But the tender strain which had been shocked into revealing itself in the unusual incompetence of his drawing of de Nerval's suicide, took over. It had appeared off and on in his travel books and in his Rabelais, and it emerged clearly in some of the *Don Quixote* plates in which his mockery of the 'sorry knight' and his dull-witted servant gave way to human and even romanticised sympathy.[105]

It touches us in the picture of 'Les Saltimbanques', apparently an early work,[106] and we can guess that it appeared nakedly in the series of paintings of the Paris underworld, made when he was twenty-two, which so shocked his contemporaries that he destroyed them. Just as the Wandering Jew was reincarnated as the Ancient Mariner, his 'Paris as She Is' was reborn years later in his impressions of London as she was in 1870.

Doré's own anxieties, both his private anguish at his failure as an easel-painter and his public distress over the loss of his native Alsace to the Germans, must have made him susceptible to misery at this time. To this state of mind was added the high moral tone of his English clerical friend Canon Harford, and also the personality and beliefs of

Le Roi des Montagnes, *1861*

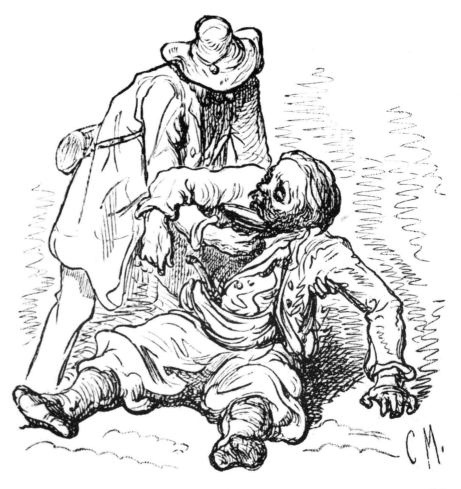

[104]   E. Ollier
[105]   A nineteenth-century approach, much developed by Daumier, which was very far from Cervantes' satirical original.
[106]   Perhaps a forefather, fifty years earlier, of Picasso's circus pictures. Daumier was painting the same subject in the 1850s and 1860s.

95

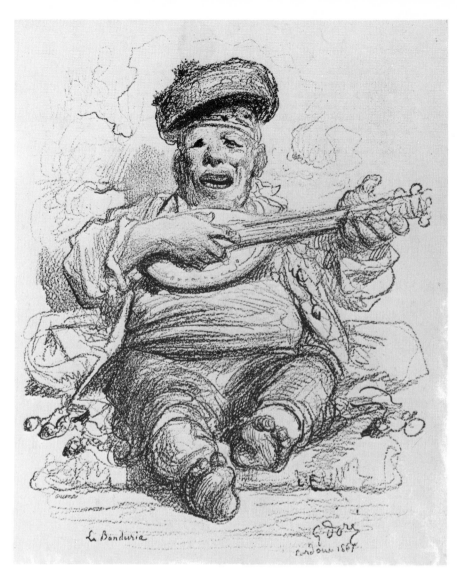

'La Banduria'. Chalk, 1867

the journalist with whom he shared his London excursions, Blanchard Jerrold. Jerrold was brother-in-law to Henry Mayhew, whose *London Labour and the London Poor* had devastatingly exposed conditions in the slums of the capital twenty years earlier, and his rather stilted text shows genuine sympathy for the depressed classes.

The aim of their book was to record both the sunny and the seamy side of London life, and Doré approached both with a certain restraint. He does not make fun of the rich, but his fashionable scenes seem to reflect commonplace convention. In the same way his records of the docks and festering back-to-backs, though emotionally loaded, show no actual scenes of open brutality. We hardly know, in fact, whether he approves of the stern scripture-reader in the doss-house or not; and it is this embracing understanding which makes his best plates so much more telling than his touching but sentimentally Dickensian waifs and beggars.

Doré's compassion here seems rooted in the solid facts of Friedrich Engels's *State of the Working Classes in England* which had appeared in 1844, and his drawings make—typically, a generation later—the perfect visual counterpart to it. It was doubtless the same admirable sentiment which he tried so hard to produce in his religious paintings. But as soon

(facing page)
*La Fontaine*, Fables, *1867*

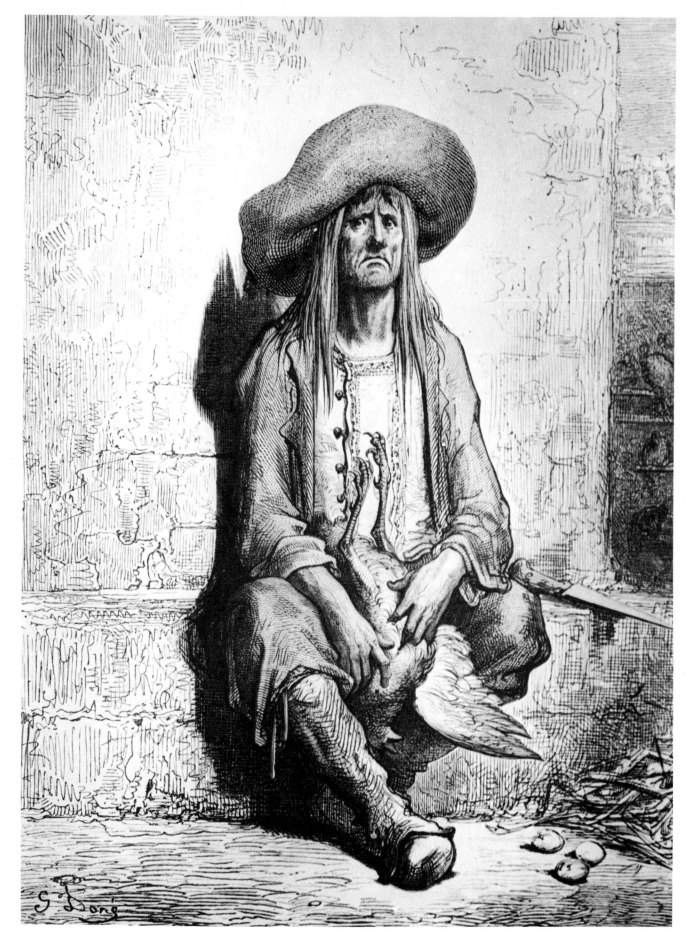

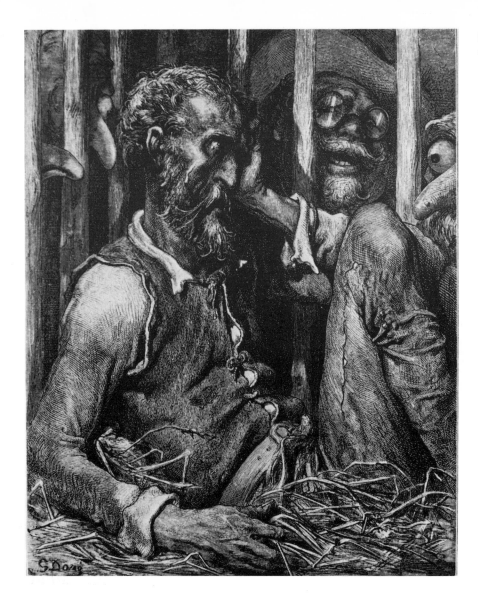

(both illustrations)
*Cervantes,* Don Quixote, *1863*

as his feet left solid documentary ground, his over-active fancy swept him out of his depth. However even here, among portentous disasters like his 'Triumph of Christianity' or the operatic 'Entry of Christ into the Praetorium', a few honestly felt images emerge. The doubt-ridden 'Neophyte' which so obsessed him that he etched it nine times[107] still makes an effect today, and some of his studies for a 'Head of Christ', with their echoes of the tormented Don Quixote, seem records of real spiritual experience.

It may be that the tears of self-pity which the German critic Albert Wolff saw pouring down Doré's cheeks as he spoke of his Salon failures[108] were the chief inspiration for these sympathies; but we know from the example of men like Dostoevsky, that great art need not spring from noble characters. In any case, these last images lend an appropriate dying fall to a career which always had a Chaplinesque element of sentimentality compounded with acrobatic entertainment. With his Ariosto as the last flutter of ebbing vitality, they symbolise the final fade-out.

It is hard to believe that he would have done better if he had lived longer. His imagination was shrinking (as his posthumously published

[107] He taught himself etching in his last years
[108] K. Farner

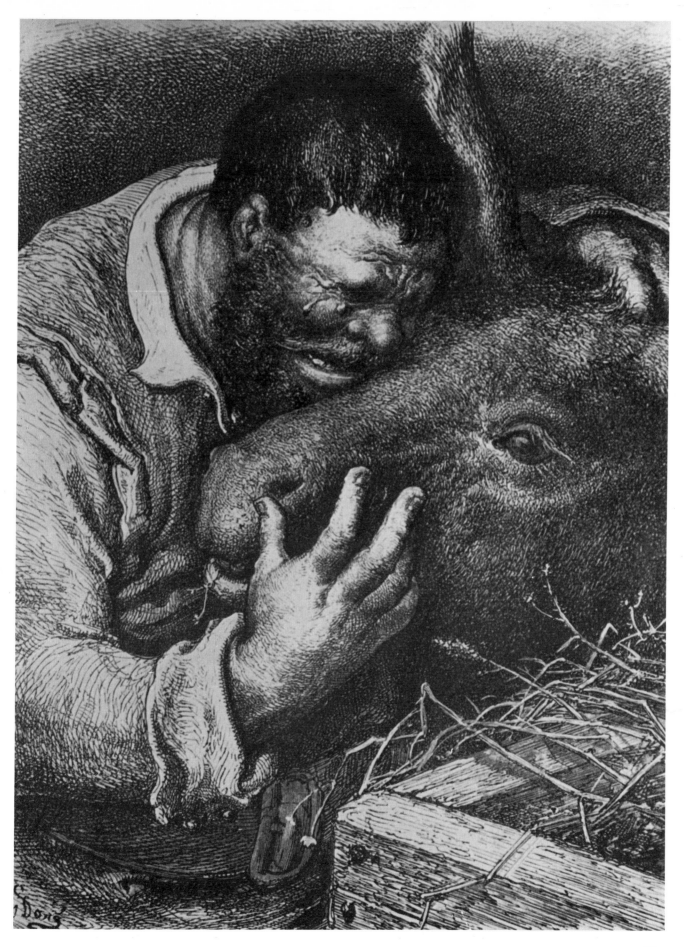

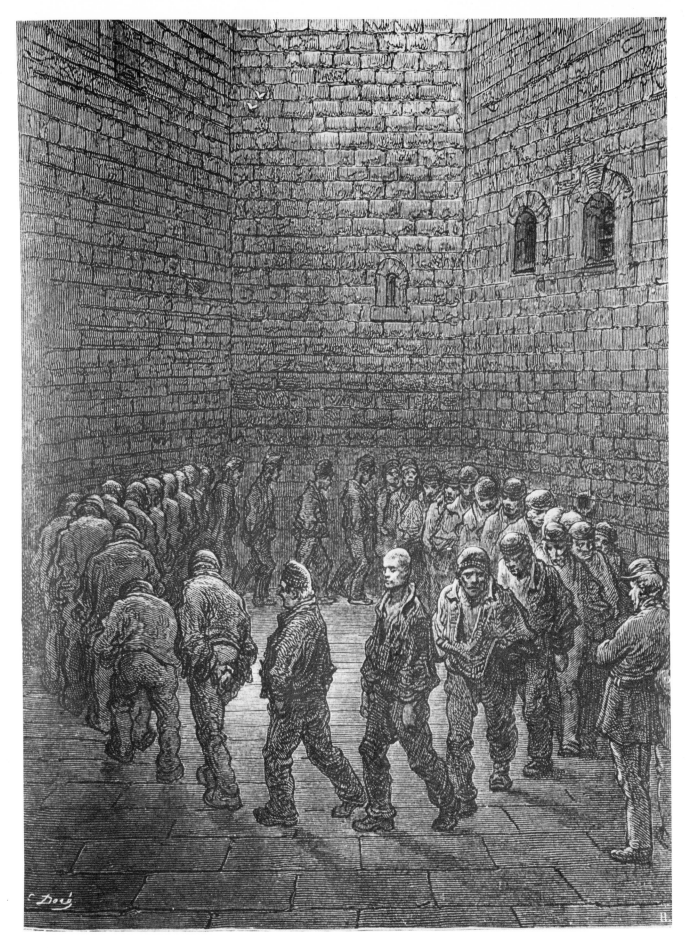

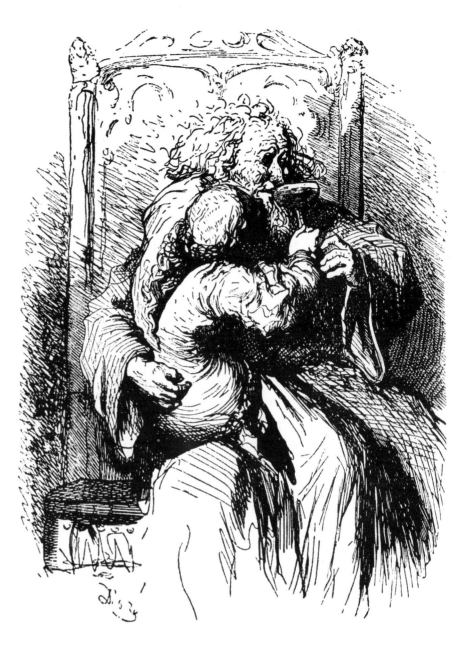

*Rabelais,* Gargantua and Panta-
gruel, *1854*

Poe drawings show) and the items left unticked on his intended roll of
fame would almost certainly have been beyond him; perhaps only
Wagner, who died in the same year, might have struck off some
tremendous pages. But Doré had done enough not only to make a
lasting personal contribution to the image-bank of his age, but also
to fertilise, and even germinate, the art of the future. He was always
inclined to follow in the footsteps of older men, and as he developed he
fell out of step with his contemporaries. He was a narrative artist
brought up in a society where critics were mostly literary men;
Baudelaire, Zola, Gautier, Saint Victor, Thoré, Blin, Houssaye and
Castagnary were eloquently demonstrating that it is more important
for a critic to write than to be right. But the tide turned in mid-century
and began to flow down channels which were to lead eventually to
abstraction, an idiom in which Doré would have been completely lost.
The birth-dates of some of his contemporaries emphasise the gap which
opened up between him and them—Manet was born in the same year,
1832; Degas two years later; Cézanne seven; Rodin, Monet and Renoir

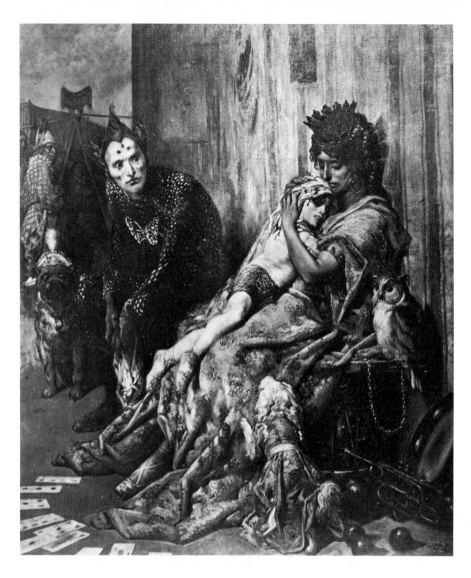

'Les Saltimbanques'. Oil, probably
about 1852

eight. The course they followed took them far from his, and he re-
joined the stream only half-way through this century, with the return
of a literary art and consequent appreciation of the Symbolists and
Surrealists.

Meanwhile his influence had been diverted into other currents.
His early drawings translated naturally into the language of the
popular strip and the cartoon film (he would have been perfectly at
home with Walt Disney's bats and dream castles, his Big Bad Wolf and
boneless heroines). His demagogic dreams of luxuriant architecture and
pullulating crowds were reborn in the epics of Cecil B. de Mille. His
approach was always extraordinarily filmic with its plunging perspec-
tives, zooming close-ups and unexpected 'camera-angles', such as the
view—perhaps inspired by his balloonist friend Nadar—of Orlando
soaring over a city and being viewed from an even greater height.

This darting fancy was part of an imaginative pace which brings him
close to some trends today. His dexterity, his versatility and range, and
his fertility often recall Picasso; and like him he could and did practice
several styles simultaneously. He was a master of improvisation. 'He
thinks, and he creates' remarked Delorme, a remark which reminds us
of Picasso's dictum: 'I do not seek, I find.' And he was obsessed, like the

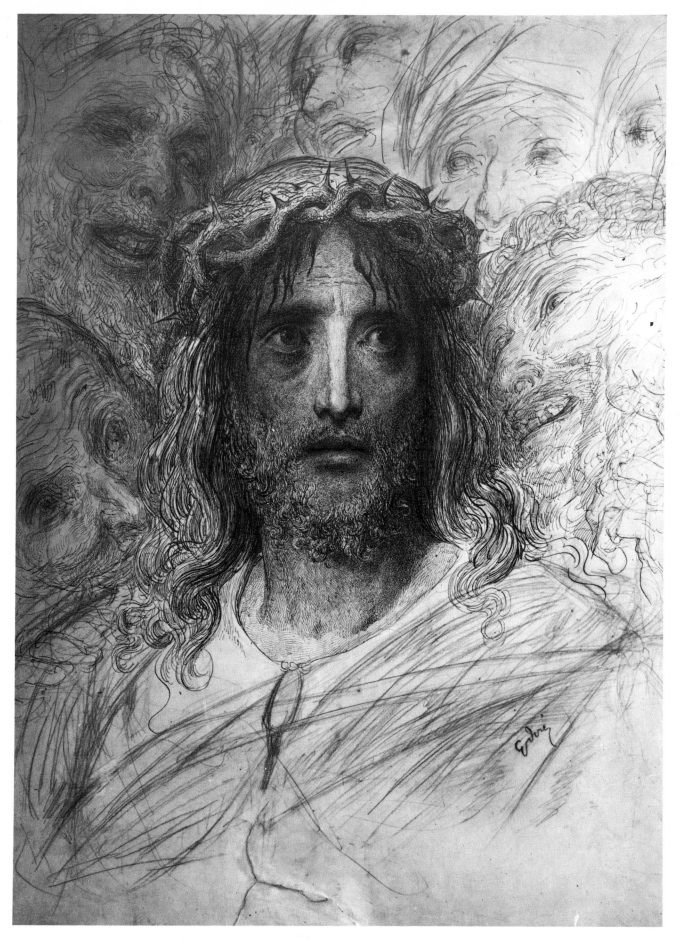

Spanish master, with trying his hand at everything—drawing, lithographing, etching, painting, sculpting, even furniture design.[109]

This very fertility was a period symptom, an expression of the productive energies let loose by the Industrial Revolution. Doré was indeed almost a symbol of capitalist development; so much so indeed that one biographer has written an excellent study wholly from this angle.[110] He exploited the opportunities offered by mass media and mechanised production and in the end he was destroyed by them. For even the finest engravers coarsened his drawing. The gap between the few original lines traced by his own hand and the often crude versions cut by an engraving tool is depressingly wide, and he must often have been seriously travestied. In one Balzac drawing an engraver is said to have solemnly cut an 'etcetera' mark intended to indicate a repeated architectural ornament;[111] and it seems that even some of his Dante drawings were altered by the engravers.[112] He suffered cruelly from bad inking and poor paper and he was undoubtedly exploited, and perhaps even tricked, by unscrupulous publishers;[113] in the end he found himself trapped by his reputation in a craft he had come to despise.

This rejection of the humble medium in which he had been so brilliantly successful was typical of the nineteenth century. It was also typical of Doré's permanently immature character. He aspired continuously towards the heights of fame; but somehow his absurd angels and the eagle of 'la gloire' always hovered just out of his reach. Had he renounced them and stayed comfortably in his natural niche in art-history he would certainly have been a happier man, but perhaps not a more admirable one.

[109] A mirror which he designed for the Russian Tsarina was subsequently bought by Jean Cocteau.
[110] K. Farner
[111] Anthony Burgess in his Introduction to *The Ancient Mariner* by Samuel Coleridge, Editione d'Arte Felix, Milan 1966.
[112] Fernand Vanderem, *La Bibliophile Nouvelle,* 1943
[113] The English editions of Doré's Balzac and Rabelais may have been unauthorised, and an even more flagrant example is quoted in Percy Muir's *Victorian Illustrated Books,* 1972.

# PRINCIPAL BOOKS ILLUSTRATED
## BY DORÉ
*(according to Henri Leblanc)*

1847    *Les Travaux d'Hercule*, Doré
1851    *Ces Chinois de Parisiens*, album
       *Les Agréments d'un Voyage d'Agrément*, Doré
       *Musée Comique*, album
       *Oeuvres Illustrées du Bibliophile Jacob*, Paul Lacroix
       *Trois Artistes Incompris et Mécontents*, Doré
       *Seul au Monde*, A. Brot
1852    *Tableau de Paris*, Edouard Texier
1853    *Oeuvres Complètes*, Lord Byron
1854    *Le Médecin du Coeur*, A. Brot
       *Le Bourreau du Roi*, A. Brot
       *Les Différents Publics de Paris*, album
       *Histoire Pittoresque de la Sainte Russie*, Doré
       *La Ménagerie Parisienne*, album
       *Gargantua et Pantagruel*, Rabelais
1855    *Contes Drolatiques*, Balzac
       *La Chasse au Lion*, Jules Gérard
       *Histoire Populaire de la Guerre d'Orient*, Abbé Mullois
       *Les Chercheurs d'Or*, J. Sherer
       *Voyage aux Eaux des Pyrénées*, Henri Taine
1856    *La France en Afrique*, B. Gastineau
       *Contes d'une Vieille Fille*, Mme de Girardin
       *L'Insurrection en Chine*, Haussmann
       *La Légende du Juif Errant*, Pierre Dupont
       *Le Chevalier Jaufre*, Mary Lafon
       *L'Habitation au Désert*, Mayne-Reid
       *Mémoires d'un Jeune Cadet*, V. Perceval
       *Refrains du Dimanche*, Plouvier et Vincent
       *Histoire de la Cordonnerie*, M. Sensfelder
1857    *Géographie Universelle*, Malte-Brun
       *Fierabras*, Mary Lafon
       *Nouveaux Contes de Fées*, Mme de Ségur
       *Aline*, V. Vernier
1858    *Boldheart the Warrior*, G. F. Pardon
       *The Adventures of St George*, W. F. Peacock
1859    *La Guerre d'Italie*, Charles Adam
       *Batailles et Combats de la Guerre d'Italie*, various
       *Les Compagnons de Jéhu*, Alexandre Dumas
       *Les Folies Gauloises*, album
       *Essais*, Montaigne
1860    *Romans Historiques*, various
       *Le Nouveau Paris*, La Bédollière
       *Histoire des Environs de Paris*, La Bédollière
       *Théâtre des Opérations Militaires en Syrie*, Malte-Brun
       *Voyage aux Pyrénées*, Henri Taine—new edition

# ACKNOWLEDGEMENTS

For this book I have drawn heavily on previous biographies—by Blanche Roosevelt (1885) and Blanchard Jerrold (1891), both of whom knew Doré personally, and by J. Valmy-Baysse and Louis Dézé (1930), G. F. Hartlaub (1967), Millicent Rose (1946) and Konrad Farner (1963) to whose illuminating comments I am much indebted.

I should also like to express my thanks to two members of Doré's family, Mme Boisnard and Monsieur Fred Jouaust; to Monsieur Paul Ahnne, Conservateur du Cabinet des Estampes at Strasbourg and Mme F. Baudson, Conservateur du Musée de l'Ain in Bourg; to Mr Brinsley Ford and Mr Paul Wallraf for allowing me to reproduce works in their collections; to Mr Theo Pinkus and Mr Christian Larson for assistance with books and photographs; and to my wife.

## ILLUSTRATIONS

All pictures not acknowledged below are from agency collections or from published books photographed by Victor Kennett.

Musée de Strasbourg, 8, 16, 45, 50, 84, 90, 96; Collection Paul Wallraf, 49; Collection Brinsley Ford, 53; Musée des Beaux Arts, Grenoble, 71; Collection P. Proute, 78; Courtauld Institute, 87.

# INDEX